Contemporary art
and its
philosophical
problems

$21.95

DATE		

CONTEMPORARY

ART

AND ITS

PHILOSOPHICAL

PROBLEMS

CONTEMPORARY
ART
AND ITS
PHILOSOPHICAL
PROBLEMS

INGRID STADLER

PROMETHEUS BOOKS
Buffalo, New York

Published 1987 by Prometheus Books
700 East Amherst Street, Buffalo, New York 14215

Library of Congress Cataloging-in-Publication Data

Contemporary art and its philosophical problems.

Papers submitted for a seminar held at Wellesley
College in the spring of 1985.
Bibliography: p.
Includes index.
1. Art, Modern—20th century—Philosophy—
Congresses. I. Stadler, Ingrid.
N6485.C66 1987 709'.04 86-25279
ISBN 0-87975-383-8

Printed in the United States of America

Acknowledgments

The essays in this collection are based on papers submitted for a seminar entitled "Contemporary Art and Its Philosophical Problems," held at Wellesley College in the spring of 1985. The participants represent a cluster of liberal arts fields—philosophy, art history, political science, mathematics—reflecting currents out of which interest in this topic sprang. A premise of the seminar was that different academic concentrations and intellectual pursuits nonetheless move around a common center. We hoped that this cooperative effort would display the relations among differing educational backgrounds and serve to supply a common focus.

The reader will have to judge the extent to which this expectation has been fulfilled, as well as our effort to teach and learn from one another. I know how much delight I took in prodding each member to find her own intellectual enthusiasm, and how much I profited from taking on the challenge of devising a means for letting each one discover and exercise her own particular skills. I thank each participant for enlarging my vistas, and especially for helping to fashion the friendships without which the 1984-85 academic year would not have been joyful: Elizabeth Alford, Camilla Arnold, Emily Berger, Leslie Birch, Susan Brainard, Anne Eu, Tatiana Flessas, Inga Freivalds, Jennifer Garden, Elizabeth Haderlein, Mary Scott Hagle, Carol Mateer, Alison Mezey, Alice Montag, Ailish O'Conner, Jill Posnick, Maria Quillard, Karen Ramspacher, Kyra Reppen, Tobi Tanzer, and Eleanor Wittrup.

Special thanks go to friends of longer standing who helped, encouraged, and abetted the entire enterprise: Nancy Baker,

Robert Crease, Michelle Moody-Adams, Ann Scales, Vicky Spelman, and to Ria Stavrides, who taught me when I was an undergraduate at Vassar. She joined us as a departmental colleague at Wellesley and continues to be a lady than whom there can be no more perfect.

Special thanks go to Anne Glickman, who offered her editorial services and plugged away throughout an extraordinarily benign summer, during which she would have preferred to keep company with her multi-talented young son, Sam.

In revising the essays that are included in this collection my memories regarding the structure of the seminar and the unifying theme I hoped to find in the papers proved fairly good—on the larger shape of discussions, also on the more salient conversations, actions, pronouncements, and absurdities that occurred in my office during the spring months of 1985. My talents proved sadly defective, however, on recalling specific journal references, middle initials of authors, dates, and other trivia necessary for presenting responsibly researched arguments. For help in getting these things right, or nearly so, I had the help of my friend and partner Steven Stadler. Without his many gifts and his sense of humor the manuscript would never have seen the light of day.

Contents

Introduction

The essays in this volume are for readers who care about the visual arts, but who are not sure how to tell art from entertainment, three-star paintings, contrived "blockbuster shows," or critical hype. This audience cannot be classified as scholarly but it does depend on scholarship. The original draft essays were written by intelligent, thoughtful individuals and should, in their present form, help educated readers find their bearings and become equipped to sort out the premises on which critics and journalists rely.

I initially proposed to publish the essays as coauthored by the respective students and myself after having taken great liberties in editing and revising them. No obstacle bars acting on this resolve. Accordingly, the name of the original author is prefixed to mine: it seems entirely appropriate to credit each of my coauthors for selecting the topics as well as for indicating the ideas that I manipulate or exploit with a view to emphasizing the central unifying theme, that is, the growing disaffection with an "anything goes" attitude toward the arts. The news is that Marshall McLuhan didn't say the last word when he said that "art is anything you can get away with." It may have looked that way in the 1960s; it doesn't now.

In "Artworks and Pricetags," Alice Montag tackles this theme by arguing that journalists like Robert Hughes and Tom Wolfe provide pseudo-explanations of alleged malpractices in the "artbiz." She shows that their contentions are antithetical and shallow: shallow, because premised on the belief that artworks are like consumer goods, such as automobiles or apparel, that can be dis-

carded and replaced by later models; antithetical, because they propose opposing exaggerations regarding the relative size of the United States population actively involved in endeavors affecting the fate or fortunes of the art world. It may be worth mentioning that the decision to include this critique of the viewpoints of two fairly prominent journalists owes quite a lot to the sentiments voiced by Sir Isaiah Berlin when he said that although "intellectuals disparage journalists . . . the course they have been following runs alongside the journalists' trail. . . ."[1] The moments when one is inclined toward the view that Hughes and Wolfe are irresponsible lightweights are outnumbered by moments that impel toward thinking that their articles merit critical scrutiny after all, and dispatched to oblivion when one considers that readers drawn to this volume by a critique of writers whose words are readily accessible and often influential can perhaps be seduced into browsing further.

If the device works, these readers will eventually learn about the primary philosophical debate represented at one extreme by the know-nothings' "I don't know anything about art, but I know what I like"; on the other, by the over-cerebrals' "I know everything about art, but don't know what I like." And most of the problems that have been plaguing persons who pause to reflect on the status of art criticism—of the critical reviews they read as well as of the critical thoughts they harbor—can, I believe, be blamed on the domineering dichotomy between populism and over-intellectualized elitism: or, what comes to virtually the same thing, between the extremes of subjective relativism (which longs for brainless affective responses) and objective absolutism (which is thrall to cold over-intellectualization). Indeed, this volume will have served its purpose if it makes readers pause to reflect on their own potential for creative, imaginative, sensitive responsiveness to art, and engenders the sort of lively, informative, and therefore enlightening discussion that can result if one dares to risk an original opinion or judgment about a painting, concert, or theater performance.

Elizabeth Alford's essay about great women artists, and Jennifer Garden's about Performance Art differ from the other contributions in that their principal aim is to set the historical record straight. A similar point should, perhaps, be made about Inga Freivalds's study of Mies van der Rohe: it continues to strike me

as being a wonderfully rich and novel *appreciation* of Mies's architectural achievements, if one wishes to distinguish appreciations from critiques.

Kyra Reppen's re-opening of the debate regarding photography's position vis-à-vis other, more traditional, art forms speaks for itself.

Of all the essays here included, "Art for Art's Sake: A Paradox" is likely to be the most elusive and controversial, since it endeavors to revive and clarify a two-edged thesis that most notably and most acerbically philosopher Nelson Goodman derides for being riddled with "philosophic faults and aesthetic absurdities."[2] But to achieve her stated and circumscribed goals, Leslie Birch need not take on the "philosophical establishment." Her *via negativa* should serve her purposes. And so she, in effect, argues against Aristotle's position that art channels surplus energies away from destructive outlets, that it clears the streets of juvenile delinquents—for example, The Dance Theater of Harlem—(the utilitarian or consequentialist position); Her jihad is also against the position that art-making is an irrepressible human propensity (Aristotle); that art is not practical but playful and provides adults adult-versions of the delights of children at play (Kant, Schiller); that art edifies (Arnold, Ruskin); and that, as the so-called "communication theory" would have it, art communicates feelings (Tolstoy); or ideas of feelings (Langer). Her conclusion is that the slogan "art for art's sake" encapsules an argument against all philosophers, poets, and playwrights who believe in or proselytize for the political or moral potency of art, and summarizes the current conventional wisdom that art is art only if it is "entirely useless." In another essay, at some other time, I should myself like to develop the positive or constructive dimension of Birch's argument. In particular, I should like to pursue the path for which Goodman makes way when, after brusquely commenting that each of the traditional philosophical theories about the nature and value of art "distends and distorts a partial truth," he observes that "what [they] all . . . miss is that the drive is curiosity and the aim enlightenment."[3] Goodman continues:

> What we know through art is felt in our bones and nerves and muscles as well as grasped by our minds . . . all the sensitivity and responsiveness of the organism participates in the invention and interpretation of symbols.[4]

Anne Eu's essay on Jackson Pollock is, in its way, as ambitious and as contentious as Birch's (and will figure prominently in my future work). She finds the stuff of genius in Pollock's oeuvre, maintaining that he created masterpieces that can hold their own among the great masterpieces of the Western tradition—those of Leonardo, Titian, and Rembrandt, for example. In making her point she relies on Immanuel Kant's attempt to distinguish between excellence in art and excellence in science, putting aside for the nonce any questions one might raise about the soundness of Kant's formulation. To her credit, she steers clear of the philosophically tempting, though erroneous, conviction that the distinction between art and science is somehow rooted in the dichotomy of feeling and knowing, of the emotive and the cognitive. Instead, Birch takes her cue from Kant's thesis about the centrality of what he terms "the free play of imagination and understanding" in the domain of art or the aesthetic, arguing that some of Pollock's utterly abstract, nonfigurative paintings give impetus to inspiration and intrigue, especially on the part of viewers accustomed to discernment by sense and sensitivity. It is also to her credit that she sees how to translate Kant's notion of "the soul of genius" into contemporary terminology that is more likely to teach us how perception, conception, and feeling intermingle, especially in experiencing a masterpiece—i.e., an artwork that Kant would call "a product of genius."

I have been suggesting that the distinguishing feature of great paintings or masterpieces, rather than paintings acknowledged to be (merely) good, mature, significant, and so on, is that the former engage feelings or emotions in a way that lesser works do not. Such a suggestion is, I believe, entirely in keeping with the spirit of Kant's inquiry and with the use to which Eu puts it. The inevitable next suggestion—that the experience of masterpieces reveals and calls forth extraordinary feats of discernment by sense and sensitivity—clears the way for a more sophisticated and complex theory than the constraints of this introductory essay admit. It does, however, seem appropriate to make some comments about a related query for which one would have to provide a full-blown answer if one wanted to do full justice to Kant's insights in the expectation of arriving at a duly penetrating and comprehensive account of the ways artistic masterpieces stand out or apart from lesser achievements. I summarize that query

this way. If Michelin can tell a three-star restaurant, should we not be able to tell a three-star painting? Some might say that to answer it, it would be necessary to trace the story to Plato, who first compared painters with pastry-chefs, though not in order to cast a favorable light on either. But that seems absurd. An investigation of one set of dominant philosophical ideas is not doomed to rehearse everything ever said or written on the chosen topic. Going back as far as the eighteenth century in which the concept of "taste" first assumed prominence in discussions of art and artistic excellence seems entirely adequate for the purpose. At any rate, the temptation to liken what Kant termed "the taste of sense" to "the taste of reflective judgment" was not actually in the air much before that time.[5]

I hope that I have said enough to make it clear that what these essays have in common is the presentation of considerations that radically undermine a good deal of the negativism or defeatism central to recent thought and talk about the arts and the status of critical judgments. None claims to say the last word about its topic. Although the several arguments point us in quite different directions for future inquiry, together they should force upon us the necessity of revising our philosophies of art if these incline toward subjective relativism in any of its various guises.

NOTES

1. Sir Isaiah Berlin, *Personal Impressions* (New York: Viking, 1980), p. xiii.
2. Nelson Goodman, "Art and Inquiry," in *Modern Art and Modernism: A Critical Anthology,* edited by Francis Frascina and Charles Harrison (New York: Harper & Row, 1982), p. 191. More specifically, Goodman argues that there are excellent reasons for the repeated failure to find a neat formula for sorting experiences into aesthetic and nonaesthetic. He dismisses the notion that there is a special aesthetic emotion, observing that it "can be dropped on the waste-pile of 'dormitive virtue' explanations" (*id.,* p. 192). Fortunately Birch's aim is to render less ambiguous this thesis from one regarding the features that may be conjunctively sufficient and disjunctively necessary for something to be an artwork; that is, the attributes at least one of which

an object must have if it is to count as a work of (fine) art. Her aim is to clarify or cast light on a viewpoint, not to demonstrate its truth. She is therefore under no obligation to rebut Goodman's argument.

3. Ibid., p. 198.

4. Ibid., pp. 198-199. To take on Goodman is to take on a formidable challenge, for his project is to devise a comprehensive and systematic theory of "symbol processing: of inventing, applying, interpreting, transforming, manipulating, symbols and symbol systems." My ambition is to succeed at a far humbler, considerably narrower task: that of explaining and defending my convictions about the importance and/or value of the fine arts in our time.

5. See, for example, Paul Guyer's virtually definitive study of the background against which Kant formulated his solution for what Guyer calls "the problem of taste," in *Kant and the Claims of Taste* (Cambridge, Mass.: Harvard University Press, 1979). Also see Paul Guyer "Pleasure and Society in Kant's Theory of Taste," in *Essays in Kant's Aesthetics,* edited by Ted Cohen and Paul Guyer (Chicago: University of Chicago, 1982).

One

Artworks and Pricetags

Alice Montag and Ingrid Stadler

When A. Alfred Taubman became chairman of the venerable art auction house, Sotheby's, he commented that "selling art has much in common with selling root beer."[1] Our sober reflections on the implications of Taubman's not unreasonable attitude toward the business of marketing artworks serves as the background of our inquiry. In the course of conducting this study, we expect to clarify the functions of criticism, and to say why two notorious critics fail us by failing to perform them.

I

"Everything is worth what its purchaser will pay," some say. What if the item in question is an artwork: is an artwork's pricetag a reliable indicator of its worth? When the work changes hands, does the transaction occur behind closed doors, or in the open— in a market that is free in the sense in which we describe colleges and universities as free markets of ideas? These questions look deceptively straightforward; they are, however, vexatiously complex. We propose to address them in this essay, aware that our conclusions will be neither definitive nor unassailable. They are answers of a form in which "conviction is compatible with . . . misgiving."[2] We offer them to advance an ongoing debate, not to settle or win it.

We speak as though engaged in articulating answers that reason or intelligence dictate, yet knowing it's not like that. In

choosing our words we thought of our readers and, in hopes of simplifying their lot, opted against recourse to the arduous prose that stands in service to the ideal of precision. It is hoped that the qualifications and restrictions we finesse will not obliterate the distinction between (logical) deduction and judgment. The following is an exercise in judgment. Deduction would be unwarranted, since reason neither compels nor dictates the moves. We enter this caveat to signal that our judgments are in one respect like judgments pronounced in a court of law: they are liable to appeal, defeasible. Unlike judges, who write their opinions for audiences of professional lawyers, we write for educated laymen whose interests intersect ours.

We also simplify. For instance, we invoke the concept of "pricelessness" without pausing to ask how the pricelessness of artworks is like the pricelessness of friends. And so we write as though oblivious of an important philosophical query. We do this because we believe that it is not directly relevant to the task at hand.

Further simplification is made by merely glancing at how the practices of auctioneers and art dealers—like Bill Bourne, auctioning Under The Tent in Centerville, Massachusetts,[3] or Leo Castelli marketing say, Op Art—resemble the behaviors of garden-variety businessmen as they find solutions to problems of production, advertising, sales, taxation, and so on. How the pricing practices of auction houses are like the pricing practices of major galleries is also, despite its interest, beyond the scope of this essay. However, in section IV we will touch on the ways in which the energies of persons who manage enterprises like supermarkets or department stores[4] resemble those expended by persons whose lives and livelihoods center on the arts.[5] Meanwhile, we dwell on them only long enough to indicate why persons who think they like some of the artworks up for sale justifiably deplore the absence of literature that clarifies the importance of comparing and contrasting the rationale underlying contemporary ways of dealing in art and in consumer goods.

We have set two tasks for ourselves. One objective is to explain the differing conclusions Tom Wolfe and Robert Hughes, two widely published critics, draw from their interpretations of the way pricetags are affixed to artworks in the 1980s, which involves interpreting their interpretations of the claim that consumers get what they pay for. The second objective is to deter-

mine whether, or in what sense, the art market may be said to be democratic, rather than socially stratified or "elitist" in some acceptance of this over-used term.[6]

By eschewing matters of aesthetic or artistic judgment— avoiding situations where we should have to make discriminations beyond dividing art into the "serious" and the "light" or "popular," "high" or "avant-garde" versus "kitsch"—we hope to whittle the topic to manageable size, at least in the first instance. Someone might object, saying that an orderly explanation of the differences between Hughes's and Wolfe's conclusions on the topic requires a detailed account of what goes wrong when art is treated as one appropriately treats comestibles, considering their beneficial or deleterious effects on the consumer, or their function and importance in society. Our reply takes the form of an excuse. Our excuse is that the issues we have selected are sufficiently difficult and contentious to merit inquiry in their own right. We will, however, make some comments on the auctioneer's observation in section VI that "people don't need root beer and they don't need a painting."[7]

In short, our aim is quite modest: to sift possible truth from patent hyperbole in current rhetoric about art and the "art business." In particular we hope to clarify the differences between the approaches of two familiar polemicists who make claims to analytical objectivity. The two critics, Tom Wolfe and Robert Hughes, as we shall see, confound the critic's task with those once assumed by Cassandras or clairvoyants.[8] If either offered detailed discussion about a specific artwork they do or do not like, it might be valuable to analyze and rebut such critiques in detail. Since neither does, we cannot carry out that exacting project here. Our essay will have served its purpose if it mutes Wolfe's trumpet call that "Today the conventional symbol of devoutness is—but of course!—the Holy Rectangle: the painting,"[9] and if it indicates an apt response to Hughes's broadside that "There is no historical precedent for the price structure of art in the late twentieth century."[10] Wolfe and Hughes are worthy targets not only by virtue of their prolific output, but because their theses seem to us to suffer from interesting deficiencies: Wolfe's, from the relative narrowness of his vision; Hughes's, from the relative extravagance of his expectations.

II

In trying to inject sobriety into discussions cast in terms as general-
ized and vague as those of Wolfe and Hughes, we shall be remind-
ing ourselves and others of Hume's[11] wisdom in counselling that,
in philosophy, moving toward grand generalizations is, almost
invariably, motion in the wrong direction. Even so, we start with
a generalization—but one of a type on which Hume also relied in
making use of what he would have termed a "species" of common
sense.

Folk wisdom says that one gets what one pays for. Like other
bits of conventional wisdom, it contains germs of truth. Fine
(human) workmanship tends to be dearer than a robot's output.
Masterfully cut gem stones cost more than their mass machine-cut
counterparts; signed calligrapher's placards more than posters
made of enlarged photocopies taken from sheets of newsprint;
gold more than copper; thoroughbreds more than mongrels; King
Tut's liqueur glass more than the glassware at the cash bar down-
town. The list could go on, except that somewhere down the road
toward art the maxim breaks down. Forgeries may cost more
than photographic reproductions of masterpieces, but they are
not worth more. An enterprising art dealer may successfully in-
crease (inflate?) the price of certain paintings without altering
their value (e.g., Leo Castelli's marketing of Op Art). Much the
same holds when critics or curators tout a newly discovered artist
(The Museum of Modern Art in New York City and Frank Stella,
in the early 1960s, for example). How is the marketing genius of
an individual like Ralph Lauren, who drives the fashion industry,
like art dealer Castelli's? They seem equally expert at creating
needs or in offering to provide their clients with goods that will
make them feel happy or better off. If Tom Wolfe is to be
believed, it would be grievously wrong to obliterate the differ-
ences. If, on the other hand, Robert Hughes is right, "the art
world now looks [and is] more like the fashion industry,"[12] i.e.,
the present condition of the art market effectively wipes out any
differences—though, by Hughes's lights, there was a time when
the grandeur and creative genius of a genuine modern master
would have eclipsed a fashion designer's marketing successes.

Before sewing one must cut. Before approaching our two
theorists another sharp distinction must be drawn: between the

nugget of truth captured in our first folk maxim[13] (also conveyed by "there is no free lunch"), and the one encapsuled in the apparently contravening saying, "them that has, gets."[14] Confirmation of the truth in this truism is not confined to the Wall Street world of business; it applies to the art market as well.

Think of the way competition among art buyers tends to select out the best (the finest of Jean [Hans] Arp bronzes are available for purchase by only the richest and the brightest who presumably have masterpieces in their possession already), and of the way major artworks make their way into institutions or foundations, already renowned for their holdings. Also recall that the winners at, for example, Sotheby auctions have tended to be institutions or foundations with budgets that presumably dwarf that of a private collector. The Norton Simon Foundation is one case in point; the foundation set up by Paul Getty is another. (According to Hughes, the latter has an income of one million dollars a day.) Artworks of quality have an uncanny way of being exceedingly expensive, hence acquirable mostly by "them that has." Moreover, an attempt to set out the factors that are decisive determinants of the prices sellers want, and the size of the budgets art purchasers bring to their shopping expeditions is virtually bound to run up against the tacit "understandings" that govern the behavior of the central actors. We suspect that it is in their interests to remain as silent as circumstances allow. We shall see how differently Wolfe and Hughes "see" or interpret facts of this type, and why Hughes has a penchant for reciting purchase prices whereas Wolfe is content to cast a side glance at the figures. Our reservations about the opposing interpretations of recent art sales transactions will emerge from our representations of the arguments Wolfe and Hughes mount.

A sketch of these objections may be helpful. We believe that when purchase prices are made public, in cases involving major acquisitions by nonprofit institutions for instance, those persons who are not party to the transaction tend to remain largely in the dark about the principal considerations affecting the tab of the purchase. It is quite possible that this state of affairs obtains as much on account of what museum curators themselves fail to grasp about their own or their associates' motives as on account of any conspiracy of silence. Although both Wolfe and Hughes want us know that they know the scenarios that eventually result

in major art purchases, we suspect they do not.[15] As we examine their narratives we shall see that they either do not know or do not remember that significant actions are overdetermined, i.e., caused by, or based on, indefinitely many factors, and explicable in various ways. Theorists who scoff at all declarations of reasons or motivations by the participating parties are, we believe, suspect on grounds of undue skepticism; those who maintain that the one or two reasons or causes they single out are alone decisive, are suspect on grounds of being doctrinaire or dogmatic.

III

What is wrong with supposing that, other things being equal, "the more a painting costs, the more it's worth"? One error should be obvious: "other things" are never "equal." For us the question cuts deep into both Wolfe's and Hughes's conceptions of the salient differences between the circumstances in which artworks are sold and purchased in the 1980s and the circumstances that prevailed some decades earlier. The clue to Wolfe's account of the significant difference is given by his invocation of the concept "icon"; the clue to Hughes's account is the centrality of the concept "fetish."[16] Although neither concept looks promising as an explanation, appearances may prove deceptive. Wolfe's "icon"[17] looks like a nonstarter because artworks do not seem to represent sacred personages to be honored or revered. (But then again, there is the ever-widening museum practice of installing bulletproof glass around objects on exhibit.) Hughes's "fetish" does not appeal at first, because artworks are not readily ranged under the rubric of being amulets of enchantment or exotic objects integral to the performance of foreign religious rites. (Is it pertinent to Hughes's case that the practice of moving objects from archeological digs to art—rather than to ethnographic—museums shows no signs of abating? Unfortunately he does not say.) We shall return to these cultural currents after first examining Wolfe's, then Hughes's, positions with a view to determining the uses to which they put the concepts we take to be their hallmarks.

IV

Let us suppose that when Wolfe tags "the painting" with the label "the Holy Rectangle," and uses the terms *icon* and *symbol of devoutness* in this context, he means to confect metaphors that highlight certain features of the way recent art buyers or collectors treat the art they acquire. Suppose Hughes's "fetish" or "fetish-ization" does the same job. Is the cashable (literal) content of their respective theses essentially the same, namely, that member-ship in today's "art club" is in some way restricted, by conversion in one case; initiation, in the other?[18] But how is falling in love with a piece of art and wanting to own it like finding happiness in a theocratic society? One answer may be that in an ideal the-ocracy, citizens feel closer to one another because their values are shared. Perhaps Hughes's position is analogous, although per-mission to participate in a ritual seems on its face less inviting to persons who enjoy conversations, in particular persons who de-light in entering into arguments with one another—a practice we call playing with ideas. If one worked diligently along such lines, one might succeed in devising an interpretive story covering both Wolfe's and Hughes's accounts. However tempting this exercise may seem, we will see that it works as a plausible coherent read-ing only in Wolfe's case.

Wolfe's notion that art is the "religion of the educated classes" in fact conflicts with Hughes's allegation that "inflation and fetish-ization" account for the deplorable condition of current art and its market. The ground common to them is merely that each seems in search of a view of the art of the 1980s that views this art as almost entirely escapist; the process of acquiring art is essentially a matter of ensuring social status. In this way the problem of the relationship between the market value and the intrinsic value of an artwork is resolved by expurgating the notion of "intrinsic value," i.e., by explaining the problem away. Some readers may also discern a shared derisiveness; we do not, inclined as we are to characterize Hughes as censorious, and Wolfe as puzzlingly agnostic. Remembering David Hume—and mindful of W. B. Gallie's claim[19] that any particular assessment of art's worth is contestable—we shall argue that Wolfe's position is unrelentingly negative and misleadingly simplistic.

Those who have followed Wolfe's career since the publication

of *The Kandy-Kolored Tangerine-Flake Streamline Baby* in the early 1960s and *The Painted Word* in 1975, may find the mockery in his recent essays about the visual arts as not surprising. Our principal target, however, is "The Worship of Art," an essay in which he implicitly promises to comment on the current state of the art market but, instead, addresses the current treatment of the arts, almost exclusively that of the Minimalist visual arts,[20] as a sociological phenomenon that reflects, or attests to, a grievous transvaluation of traditional American values.[21] He avers that art has become the "religion of the educated classes," a claim that implicitly carries an 1985 dateline. This makes us wonder what has changed since 1975 when Wolfe, sketching the routines of a modern churchman "who was featured in the Religion sections of both *Time* and *Newsweek,*" observed that the gentleman in question, a great supporter of the arts, had his living room redesigned in such fashion that "the painting frame . . . replaced the cross as a religious symbol."[22] Is the change that, nowadays, churchmen could not afford such paintings or frames? Possibly. Or is it that Wolfe is now able to specify the precise longitude and latitude where the chic art collectors live, whereas he was unwilling or unable to say where the modern churchman resides? This is conceivable but unlikely, we think, since "These Radical Chic Evenings" (1966) makes a similar point, and specifies that Richard Feigen, "owner of Feigen Gallery, 79th near Madison" attended the party thrown by Leonard and Felicia Bernstein for the Black Panthers, in their "thirteen room penthouse duplex" on Park Avenue.[23] Whatever has changed in the intervening decades is not, or is not merely, geographic.

Cavils aside, let us return to Wolfe's most recent essay. In it he observes (perhaps correctly) that ownership of serious or avant-garde art is the prize asset of persons and institutions in the two percent of the U.S. population that constitutes our moneyed aristocrats: the richest, the brightest, "the top and out-of-sight." Wolfe may even be correct in maintaining that these barons of bullion hang out in the Upper East Side of Manhattan. They may tend to own residences in the choice twenty blocks of Manhattan. We are, nevertheless, strongly inclined to doubt Wolfe's contention about the place, role, and function of art for these posh denizens, or anyone else in America's centers of regentrification. One claim we question is that art has become the "religion of the

educated classes."[24] None of our friends regard their paintings as "Holy Rectangles," and we would not interpret what they do and say about the artworks in their living rooms as bases for inferring that they regard these works as "symbols of devoutness." Unfortunately Wolfe's anecdotal essay falls far short of documenting that Art or The Museum has become anyone's shrine of worship.

We also contest Wolfe's position that art is (only?) where the money is, and that the pricetags on works of art effectively keep them hidden from all save an elite few. The multiplicity of lively art forms extant in the United States casts serious doubt on the credibility of any diagnosis of the current state of art in this country that concentrates on only one or two art forms. Wolfe's thesis, we suspect, suffers from this relative narrowness of vision. Second, counterexamples exist even within the art forms to which Wolfe restricts his focus: the highly accessible Vietnam War Memorial in Washington, D.C., for one; the Philip Guston painting in a friend's house several hundred miles from Manhattan, for another.[25] We judge that these works are admired, and loved, for reasons having little to do with worship; nor, to the best of our knowledge, were they purchased at seven figure prices.[26]

In a more charitable vein, we concede that several cases provide supporting evidence for the "art-church" thesis: Nevelson's Chapel in the Citicorp Building in Manhattan and Rothko's Chapel (although it is situated in Texas)—they've got religion and merit the accolade of High Art. The same holds for Matisse's chapel in Vence, France, and for Chagall's synagogue, also in southern France. Although it would be possible to extend this list, we rest our defense on these four supporting cases, suspecting that actual churches and synagogues created or enhanced by painters and/or sculptors are not what Wolfe had in mind.

The narrowness of Wolfe's outlook reminds us of the thin band of contemporary music deemed "serious music," in particular such compositions as Elliott Carter's string quartets and Anton Webern's late cantatas. Others might include most Schoenberg music in this category.[27] Still others, remembering Thomas Mann's novel *Doctor Faustus*, might join us in recalling the composer-character Adrian Levekuel, who, convinced that serious music had become too difficult to write, speculates:

Isn't it amusing that this art, for a long time considered a means of release [for everyman] now, like all the arts, needs to be redeemed from pompous isolation. . . . The elevation of culture as a substitute for religion. . . . Soon art will be entirely alone, alone to die, unless it finds its way back to the folk.[28]

The irony is that Levekuel's criterion for the death of music—its "pompous isolation"—and his prediction of its silent death seem viable theses about the status of "serious" contemporary music, whereas Wolfe's similar arguments concerning Minimalist painting or sculpture are unconvincing. Mann's Levekuel is a failed creator, undone as a result of measuring his work against the standard set by earlier masterpieces (the "burden of the past" in W. Jackson Bate's memorable terms).[29] To the best of our knowledge, Wolfe's experiences do not parallel the composer-character Levekuel's.

What is Wolfe's conception of his role? Although there are, no doubt, taste-makers[30] (Clement Greenberg was one for several decades; there are, at present, several contenders for this title), Wolfe does not seem to covet this dubious distinction.[31] It is difficult to tell precisely what he is after. The most relevant precedent is the role of Marshall McLuhan two decades ago. A significant difference between the two men concerns McLuhan's status as a tested scholar, also, perhaps, the Joycean character of his wit, the scope of his learning, and his quickness to the draw. Wolfe's deficiencies in this (these) regard(s) may explain his failings as diagnostician of culture. Our hunch is that, in addition to the relative narrowness of Wolfe's vision, his work is marred by its relentlessly scoffing tone. Having no clear sense of what, precisely, Wolfe values positively, it is impossible to calibrate his position vis-à-vis the situation of art in the 1980s.[32]

V

Robert Hughes appears poised to contest Wolfe's assumption that art is where the money is, and that the pricetags on artworks effectively keep them hidden among the denizens of Manhattan's Upper East Side; hence from most potential art viewers. He says as much when he asserts that "hundreds of thousands . . . collect [art],"[33] and, in our pet phrase, that nowadays the "Art World . . . [is] the cultural equivalent to Disneyworld."

Hughes contends that "extreme inflation and fetishization" characterize artworks in this decade, a claim that is both easier and harder to tackle than Wolfe's anecdotal narrative. It is easier to handle because it is replete with clever generalizations (the remarks cited above as well as such gems as that we are witnessing "a kind of environmental breakdown in the art world"). Hughes's contention is a more difficult target by virtue of the shapelessness of his argument (with points ranging from "the art impresario and the art star" of Georgian times, to admittedly "impressionistic" cost-conversion rates of works purchased by such collectors as Augustus III, King of Poland and Saxony, who in 1754 "paid 17,000 ducats—the equivalent of 8,555 British pounds in the currency of George II—to the monks of Piacenza, for Raphael's *Sistine Madonna;* and to the proposition that the pound of George II is worth more than 780 times the pound of Margaret Thatcher). Hughes even predicts "the art-market's crash by 1990." Since we are interested less in puncturing the webs of Hughes's logic than in calling attention to the implications of the principal thrust of his argument, we will pause to question neither the data from which his cost-conversions are derived, nor the grounds for his prophesy of doom.

A centerpiece of Hughes's portrait of the present is the avid know-nothing collector who buys or backs artworks produced by anyone carrying proper academic credentials. The sheer number of persons answering this description, as well as the inability of such souls to discriminate good or serious art from counterfeits are, we surmise, factors responsible for Hughes's case that art prices have taken a quantum leap upward since the 1950s. Hughes writes:

> The difference today lies in the sheer number of people doing the buying and selling and the porousness of the barrier that separates the language of disinterested evaluation from sales talk.[34]

How does Hughes know that this observation is accurate? Has he checked it against others? Perhaps one should not ask. Some might be persuaded by his claim concerning the number of active participants in the "Art World," but balk at the pronouncement regarding the "porousness of the barrier [separating] . . . evaluation . . . from sales talk." What Hughes says and implies about

gallery owners does not echo our experience: the galleries with which we have dealt and the personnel who work in them have behaved as though they knew we would not return as customers if they mistook their role (i.e., if they behaved like experienced used car salesmen—sizing up and catering to the needs or vainglories of persons who walk into their salesrooms—rather than fairly honorable, discriminating folk who are able to provide reasons for the critical evaluations that inform their decisions to represent certain artists and reject others).

Hughes's failure to document his generalizations about prices and values is disquieting, as is his failure to take a properly analytic look at the implications of his debonair pronouncements. The need for such analysis seems particularly acute with regard to the implication that there is, if not a direct causal connection, at least a statistically significant correlation between the alleged increase in the number of persons involved and decrease in the quality (or intelligence) of their concern about the possibly positive value of joining an ever widening audience for art.

Another of Hughes's sallies attacks the New York Metropolitan Museum's acquisition of Rembrandt's *Aristotle Contemplating the Bust of Homer* (for which Hughes says the museum paid 2.3 million dollars). We do not quarrel with Hughes's figure, or with his surmise that "money talks," but we do object to the statement that, in consequence of its cost, "the painting was [simultaneously] imposed on us as an authoritative object . . . and withdrawn as a communicative one."[35] Please speak for yourself, Sir, and leave "us" out of it.

Our conclusion: *If* a case is to be made either for the exclusiveness of the "Art-Circle," or for its mass membership, it has yet to be made.

VI

Earlier we promised to explain why, despite the flaws in Robert Hughes's defense of his prophesy of gloom and doom, the scale on which we balance Wolfe and Hughes tips in favor of the latter. We mentioned then, and wish to repeat now, our guess that Hughes's dim view of the current art world is informed by romantically extravagant expectations that, even if dismissed as

unrealistic or partial, at least make it possible to calibrate his assessment: something we are unable to do in Wolfe's case.

Judging by *The Shock of the New*,[36] Hughes has some standards, some strong opinions about when, and by whom, his faith in the positive value or importance of Modernist art was shored up. The works he deems "dazzling achievements" are few; as are the painters capable of producing genuine masterpieces—fewer and farther between than we would so judge, but this is immaterial for our present purposes. What matters is that there are such, and that, by reviewing the works and Hughes's words about them, one can venture guesses about why Hughes finds "the present" wanting.

Hughes seems to have four Modernist heroes: Diego Rivera, Pablo Picasso, Max Beckmann, and Willem De Kooning.[37] He credits each with creating one masterpiece or a few masterpieces in their most robust days. Diego Rivera's grandest achievements are not identified by name, Picasso's is: *Guernica*. Hughes celebrates it as:

> the last of the line of formal images of battle and suffering that runs from Uccello's "Rout of San Romano" through Tintoretto to Rubens, and thence to Goya's "Third of May" and Delacroix's "Massacre at Chois."

Guernica is singled out not solely for continuing a grand tradition of history-painting. Hughes also praises Picasso for capturing the brutality of an event that lives as "the arch-symbol of Fascist barbarity."[38] In a similar vein, Beckmann is praised for the few canvases in which he succeeded in expressing his "sense of moral outrage" at the horrors of the First World War, replacing "Expressionist self-pity by a larger compassion for the victims of history."[39] To see what De Kooning could do with the Expressionist tradition, we are counselled to "go to the 'Women' he painted between 1950 and 1953."[40] One passage about De Kooning's achievement merits quoting in its entirety because it should serve to close the circle, tying our conclusion to our beginning. Hughes writes:

> De Kooning's interest in idols and oracles . . . was hardly unique, but [he] . . . gave it a peculiarly vivid edge by connecting it both

to Expressionism and to the . . . indigestible vulgarity of American mass images.[41]

Yes, Hughes hungered after "apoplectic tumult," Expressionism enlisted in the service of heroic historical causes, and paintings with the power to rally revolutionaries.[42] Unless his outlook has altered radically since 1981, we surmise that he is, in his dour conception of American art in the mid-1980s, entirely consistent.

In contrast to Wolfe, Hughes's consistency is made of stronger stuff. We know what he values. The outstanding question is: does he know why he values art, or why someone in his position should understand the value of valuable art in his time and in ours?

VII

What has led Wolfe and Hughes astray? What is it about the situation of art in the 1980s that has led them to look at pricetags rather than at the works tagged by them? What makes them look at the social status of art owners rather than at the status as artists of the art makers or at the artistic status of the works themselves? We do not expect Sotheby auctioneers to understand the art they sell any more than we expect presidents of publishing companies to understand the meaning of the poetry they publish. We do, however, expect critics to be sensitive to and sensible of the importance of art; and we expect them to be intelligent and articulate with respect to the artworks they choose to write about. Why do Hughes and Wolfe foil these expectations? Those of us who think we like some of the artworks they disparage and think it right to like them, feel particularly cheated: we need someone to articulate the reasons. We also feel sorry for those who do not trust their instinctive preferences, and for the many others who stay away from the art of the 1980s because they are completely baffled by it.

One unsatisfying answer is that too much talk about money enters into the discourse about art, making it difficult to sort out the values of art collectors and the staff members of the acquisition departments of American museums. Money enters the picture because we are a consumer society. The explanation is unhelpful,

though quite possibly true.

Another way to pursue the question as to what makes the contemporary art world susceptible to grievous misconstrual would go like this: We continue to believe that art can and should bring our common needs into focus, elucidate our inchoate awarenesses or twilight longings, exorcise our demons, and embody our dreams. The art of the 1980s, by failing to address such substantial themes, fails to provoke the kind of thoughtful reflection we want art to engender. But this answer, couched in these terms, seems unpromising as well: we have, after all, come to love nonrepresentational artworks and have found critics who succeed in informing our responses to them, often by drawing comparisons that enrich our appreciation of the new while adding to our understanding of works drawn from art's past. One case in point is juxtaposing a Matisse odalisque with paintings recovered by archeologists when they tunneled inside Egyptian tombs; a Cubist Braque, with the vista of an ancient Greek town—Santorini, for instance. Or take the way our appreciation of David Smith's *Cubi* is enhanced by the suggestion that it inconstantly conjures up "the illusion of rough-hewn marble blocks and all the attendant associations with the sculpture and architecture of classical antiquity."[43]

What makes critics mistake the task of criticism for that of writing social commentary, or turn its particular challenge into an opportunity for self-advertisement—as Wolfe and Hughes seem to? Our first approximation toward an answer is that their work is symptomatic of a pervasive cowardice or failure of will that manifests itself in an apparent tendency to evade or avoid taking responsibility for venturing critical (evaluative) assessments—all the way up and down the line: from grade school teachers to college professors. Although we are in no position to explain or trace the etiology of this disease, we can protest it. A reason for protest is that, by throwing in the sponge, those who could and should tell good from bad, genuinely promising from merely meretricious novelty, creativity from academicism, end by inching art (innovative as well as traditional) further toward the periphery of serious concern. We continue to believe in the enlightening and/or civilizing value of good art as well as in the enlightening and/or civilizing value of art-critical discourse. Even if Kant was overly optimistic in supposing that continuing such discourse can bring about the communality of value that makes individuals

comprehensible to one another, we think it worth the effort. Ludwig Wittgenstein pointed to a similar moral in his oracular pronouncement that "if a lion were to speak we would not understand him."[44]

NOTES

1. *Wall Street Journal* (September 18, 1985): 1 and 26. We shall have occasion to return to the remarks attributed to Taubman, in section VI.

2. We paraphrase Denis Donoghue's words, capturing the spirit of his argument for continuing the art/criticism dialogue—continuing to discriminate good from bad, true from merely effective—rather than taking recourse in some form of relativism or subjectivism. See Denis Donoghue, *The Arts Without Mystery* (Boston: Little Brown, 1983), p. 106.

3. *Cape Cod Times* (August 6, 1986): 10.

4. It seems too early for sober reflection on the impact of A. Alfred Taubman, whom the *Wall Street Journal* styles an "auction tycoon," and quotes as saying that "selling art has much in common with selling root beer. . . . People don't need root beer and they don't need a painting, either." He explains that "we provide them a sense that it will give them a happier experience." *Wall Street Journal* (September 18, 1985): 1 and 26.

5. We are thinking of matters like marketing on the basis of name or label recognition that dramatically inflate an item's cost: Ralph Lauren's cottons, for example; in the current German art world the same seems to hold regarding paintings by Joseph Beuys, Anselm Kiefer, etc. See Paul Taylor's "Cafe Deutschland," *ARTnews* 85 (April, 1986): 68–76.

6. We choose these queries, we confess, as much in response to public pressures as to our own intellectual bents. Perhaps this serves to strengthen our belief that we are advancing a current dialogue.

7. *Wall Street Journal*, p. 26.

8. We single out Wolfe and Hughes, knowing that there are other candidates. For a painting with a broader brush, see Carter Ratcliff's "Dramatis Personae, Part I: Dim Views, Dire Warnings, and Art-World Cassandras," *Art in America*, 73 (September 1985): 9–15.

9. Tom Wolfe, "The Worship of Art," *Harpers* (October 1984): 63. See also Wolfe's "Proper Places," *Esquire* (June 1985): 194–200.

10. Robert Hughes, "On Art and Money," *New York Review of Books* (December 6, 1984): 23.

11. David Hume, "Of the Standard of Taste," in *Hume's Ethical Writings*, edited by Alasdair MacIntyre (London: Collier Books, 1965), pp. 275-295.

12. See Hughes's claim, p. 26.

13. We are assuming that the maxim is supposed to bear the weight of argument, following Hume's procedure in the essay cited in note 11 above.

14. Although this may seem to beg the central question, we are persuaded that reliance on this maxim *is* to the point. In proceeding as we do, we believe we are preserving the spirit of the observation Ludwig Wittgenstein once made that "what we really want, to solve aesthetic puzzlement, is certain comparisons—grouping together certain cases," where the grouping is not to be accounted for in psychological terms. See also Ludwig Wittgenstein, *Philosophical Investigations*, translated by G. E. M. Anscombe (Oxford: Blackwell, 1953), p. 203.

15. This pertains to the second of our stated objectives, namely, to determine whether, or in what sense, the art market may be said to be democratic or elitist. Facts of this type serve to show that the market is elitist.

16. Although we are aware of the allusion to Marxist value theory in Hughes's attack on the commodity fetishism of the art world, we put that consideration aside in this essay. The same holds for section V below.

17. Yes, we are taking Wolfe's "icon" metaphor literally in this instance.

18. Another interpretation would be that Wolfe means to imply that there are still persons who believe that money can buy salvation.

19. W. B. Gallie, "Essentially Contested Concepts," in *The Importance of Language*, edited by Max Black (Englewood Cliffs, N.J.: Prentice-Hall, 1962), pp. 121-146.

20. For our purposes Wolfe's ventures into the domain of architecture are off limits. But see *From Bauhaus to Our House* (New York: Farrar, Straus and Giroux, 1981).

21. We say "attests to or reflects" advisedly. Wolfe seems unwilling to pinpoint the direction of influence.

22. "The Modern Churchman," in Tom Wolfe's reader, *The Purple Decades* (New York: Berkley Books, 1983), p. 330.

23. "These Radical Chic Evenings," ibid., pp. 181-197.

24. It seems worth noting that Wolfe conflates two distinguishable claims. We treat them as distinct claims: (1) that art is the religion of the educated classes and (2) that art is where the money is and price keeps it inaccessible to most.

25. As our readers will notice, we have found it necessary to raise this difficult question in a somewhat foreshortened form in order to proceed. Thus, for example, we mention a piece of public sculpture in the same breath as a private painting.

26. It's not clear to us how Hughes reached his conclusion that such works now go at "seven figure" prices; nor is it clear what he intends when he writes about "the emblematic power" of these artworks.

27. On this point we particularly recommend an essay that Brian Trowell wrote for the *Times Literary Supplement* entitled "The Composer in the Marketplace" 850, no. 3 (December 26, 1975): 1530–1531.

28. Thomas Mann, *Doctor Faustus*. Translated by H. T. Lowe-Porter (New York: Vintage Books, 1971), ch. 31.

29. See W. Jackson Bate, *The Burden of the Past and the English Poet* (New York: W. W. Norton, 1972). In one particularly eloquent passage Bate reminds us that Goethe took great delight in not having to compete with Shakespeare because, in Goethe's view, only native English speakers need work in Shakespeare's shadow. It seems likely that Thomas Mann intentionally echoed Goethe in fashioning his Levekuel.

30. Hughes would most likely say persons "who exert . . . a real force on taste"—which we find somewhat overblown. We also recall reading an article in which the extension of our term "taste makers" was narrowed to exactly one, called "the Czar of taste." (This passage is taken from a copy of the *Neue Zurcher Zeitung* that we no longer have.) We're too American to think or talk of Czars.

31. Perhaps not so "dubious" after all. In 1981 Greenberg himself gloomily prophesied a future in which critics and curators would cower from stepping into his shoes; see Clement Greenberg's contribution to a discussion in "Art Criticism" *Partisan Review*, 48, no. 1., (1981): 36–50. Manuela Hoelterhoff sides with Greenberg, faulting the Whitney Museum of American Art for mounting muddle-headed exhibitions, and claiming that "major curatorial voices are either gone or sidelined." We also feel inclined to echo her rhetorical question: [Is] there no one at the Whitney with an editing pencil?" See Manuela Hoelterhoff's commentary "Sofas to Soda Siphons: Consumerism at the Whitney" *The Wall Street Journal* (September 26, 1985): 28.

32. In view of this, why make Wolfe a centerpiece of our essay? The answer is simple: Wolfe is prolific, and his readership is large. Exposing the clay feet of an idol isn't an idle pastime.

33. Hughes, p. 26. The passage merits quoting in its entirety. Hughes writes that "35,000 painters, sculptors, potters, art historians, and so forth graduate from the art schools of America every year. . . . Behind them are millions of people interested in art . . . and hundreds of thousands who collect it." He may well be right; unfortunately, we do not know how to document his figures.

34. Ibid. The emphasis is ours, to underscore the elementary logical significance of Hughes's conjunction. Recall that each lesson in "truth tables" informs the student that a conjunction is false if one of the conjuncts is false; that a conjunction is true if and only if both conjuncts are.

35. Hughes, p. 35.

36. Robert Hughes, *The Shock of the New* (New York: A. Knopf, 1981). The jacket gives something that may be construed as the equivalent of a subtitle, namely, "The Hundred-Year History of Modern Art: Its Rise, Its Dazzling Achievement, Its Fall," and delivers on its implicit promise. This is to say that in the book Hughes implicitly tells what he regards as the standards set by his Modernist heroes.

37. Ibid., pp. 108, 109, 290, and 295-296. Our list differs somewhat from Carter Ratcliff's, as does our interpretation of Hughes's underlying rationale. This may be owing to our familiarity with a volume that Ratcliff has not studied (Hughes 1981): see Ratcliff, op. cit.

38. Hughes, *The Shock of the New*, p. 110.

39. Ibid., pp. 290-291.

40. Ibid., p. 294.

41. Ibid., p. 296.

42. He does not *really* depend on the cultural trends to which we alluded in section II. By now it should also be evident that Hughes's reference is not to fetishes and shamans, though he does take account of the potency of images we associate with what Hughes terms the penchant for "primitivization" evidenced in Modernist masters. One central thesis of this essay is given in Hughes's statement that a "Picasso or a Bonnard is simply the price of an object." Ibid., p. 23. Elsewhere in this volume, Jennifer Garden expands on reasons for refusing to accept the idea that artworks are "objects," see chapter 6.

43. Jonathan Silver, "The Classical Cubism of David Smith" *ART-news* 82, no.2. (February 1983): 103.

44. See Ludwig Wittgenstein, *Notebooks, 1914-1916*, edited by G. H. von Wright and G. E. M. Anscombe. Translated by G. E. M. Anscombe (New York: Harper & Row, 1961), p. 78.

Two

Art for Art's Sake: A Paradox

Leslie Birch and Ingrid Stadler

When philosophers write about art, they have, since Plato's time, tended to concentrate attention on the artist, the maker or creator of artworks. Some make the artist and his/her relationship[1] to art the principal target of philosophical criticism. (E.g, what would have happened to the history of music had there been no Mozart? Would there have been a Mozart had there been no Viennese school of composers and/or compositions? Does the artist make history or does history make the artist?) Others, notably historians like Arnold Hauser,[2] stress questions about the relationship of any given artist to the socioeconomic conditions of the time asking, for example, about the societal status of Mozart in the Austria of his day. Being neither a ruler nor among the ruled, was his relationship to his patron more like that of servant or of all-purpose entertainer? More precisely, how did art-making stack up against cake-making, soldiering, soul-saving, or fishing along the Donau Canal? While questions of this type are doubtless worthy of attention, they tend to obliterate a question that seems to merit scrutiny: What about the audience (the viewer, the reader, and others) for whom these works were created? Will just about anyone find the work accessible, or only an elite few? Are some people born to be lovers of great art, while others are destined to applaud punk? Is art appreciation a capacity that one inherits, that is acquired by practice (like playing the flute, for example), or one that a friendly environment can nurture?

We are strongly inclined to agree with the poet Wallace Stevens when he says that a poem comes alive only when it

sparks the imagination of the reader. We believe that it is important to reflect on, and to articulate, the characteristic features of the (ideal) respondent's experience, or his "aesthetic experience" as it is sometimes called.[3] Our aim in this essay, therefore, is to detail and elucidate the factors that distinguish aesthetic experiences from others, such as (1) solving a problem set by a scientist for his students, (2) solving a puzzle (e.g., a crossword), or (3) solving a riddle like that of the Sphinx. Put in terms philosophers may like better, our aim is to elucidate the aesthetic appreciation of x from understanding x in a theoretical sense, where understanding x is to appropriate it, to claim possession of x's meaning. Our thesis is that, distinct from theoretical appropriation, aesthetic appreciation is a matter of understanding a suitable x and taking delight in x's appearance.[4] Others may better understand if they remember that Virginia Woolf says that the human condition is like an audience between the acts of a play (and perhaps compare this with Federico Fellini, who likens it to a circus) and that for aesthetic appreciation the incompatibility of Woolf's and Fellini's viewpoints is immaterial, at best of secondary importance, circumferential.

The task we have set ourselves is to philosophically scrutinize the processes that enter into the experience of understanding and appreciating a work of art. To make our project manageable we have decided to concentrate on the aesthetic appreciation of one art form: the art of painting.[5]

What needs to happen in order to make possible the experiencing of an artwork in a way that aproximates the ideal aesthetic experience? Some of the conditions that must be met if such an experience is to be possible are not—or not entirely— under the control of the viewer. For example, the actual setting in which the viewing is to take place may interfere with rather than enhance the opportunity of attending to the painting in question. Think of the lighting in Boston's Gardner Museum, for example, especially the reflections that interfere when one wants to give serious attention to that museum's prize possession, the Titian *Spanish Dancer.* Think of the obstacles, in the form of small hordes of humans, that virtually bar access to De Vinci's *Mona Lisa* in Paris's famed Louvre. Although we have not actually tried to see Picasso's *Guernica* in the Spanish city for which it is named, we strongly suspect that the bulletproof glass that the Spanish

government added as a security measure detracts from the visitors' excitement that we recall feeling when we first got a good look at it in New York City's Museum of Modern Art, where there was no glass barrier. This list could be extended. These instances should suffice, however, to make our point.

Next, consider such factors as the weather on the day of one's initial visit. It is unlikely that any painting, even a masterpiece like *Guernica*, or Rembrandt's *Nightwatch*, will give the serious potential viewer much of a charge when viewed in hot, humid weather, or when the temperature drops below freezing and the winter winds seem to burn the skin on contact. Ideally one would, of course, make the pilgrimage on a delightfully crisp, sunny, springtime morning. The fact remains that weather conditions are not within the viewer's control, supposing of course that he cannot choose the day of his first visit.

There are other such factors: the curator's decision about how and where the painting in question is to be hung; the municipality's decision to allow workmen to begin drilling for a building's foundation in the street outside; a mother's decision to visit the museum when you are there, and to ignore the effects of the shrill screams emanating from the tiny thing in her arms on the visitor standing to her right, and so on. For our present purposes, the list need not be exhaustive.

Certain other conditions are, however, in varying degrees, within the viewer's power to alter or control. Among these are the ones cited by David Hume: "perfect serenity of mind," a "delicacy of imagination," "practice [in] the discernment of beauty," frequent experience in "form[ing] comparisons between the several species and degrees of excellence, and estimating their proportion" to one another, and a mind "free from all prejudice."[6] We are inclined to agree with Hume's supposition that these are factors that a person of normal intelligence is capable of attaining, provided he is determined to do so.

Pace Hume, we are, however, somewhat taken with the maxim that "mob thought is the enemy; individualism, our rebel hope."[7] Recall that Hume bases his argument on the belief that the most discerning critic is one who is best attuned to the voices of other, earlier, critics. He echoes them, dares no risk; and so, in Hume's picture of him, this critic seems entirely unable to take his own stand on anything not already appraised or tested by time.

In consequence, Hume leaves us with the distinct impression that, for the ideally qualified critic, there is no place for innovation or experimentation in the arts.

We are confronted, then, with a paradox: On one side, there is the argument that art's audience, the viewer, can take steps requisite for experiencing an artwork fully and appreciatively—an argument implying that art is created to provide the viewer with an opportunity to delight in, and profit from, the experience of encountering that object. On the other hand, there is the rationale that art exists for its own sake and not for the sake of providing the viewer with a new perspective on his environment or on his world. Not that we know exactly how the expression "art for art's sake" is used; but our best guess is that it is used in contexts in which it serves to deny that art either does, or should, serve the best interests of a political party (e.g., advance the cause of communism, symbolize the heroism of Hitler's Nazi Party,[8] instill youth with patriotism—as in "Uncle Sam Needs You" posters, commercials, and the like), or that art's obligation is to teach the wonders of God's handiworks (Christian art from its birthdate in, roughly, 500 A.D.; Chinese art since Confucius; Buddhist art since the Buddha; etc.). There is also the "art as a sugar-coated pill" theory, of which moralizing critics and philosophers are fond. In sum, "art for art's sake" would seem to be a handy tool for smashing a variety of other viewpoints: all those, that is, that endow art with a purpose, be it teaching the truth about reality, serving a cause, inculcating religious belief, rousing patriotic fervor, or inspiring to moral virtue. Immanuel Kant may not have been the very first to say it, but he said it well when, in the "Third Moment" of "the Analytic of the Beautiful," he spoke of beauty as the quality one ascribes to an object on grounds of its appearing to exhibit "purposiveness without a purpose."[9]

Our paradox circumambulates the point that art both has and does not have a purpose. How is it possible for any one thing to be characterized in two seemingly opposing ways? Let us begin by reconsidering our two arguments with a view to determining what is true in each, and how both leap to conclusions that are not entirely warranted. Let us begin first with the proposition that the purpose of art is to delight and enlighten the viewer.

This argument must be premised on the assumption that what holds for some works of twentieth-century art holds as well for

works created as long ago as the beginnings of civilization in an-
cient Egypt. If the assumption is granted, the argument proceeds
without a hitch. But why grant it, given what we now know of
the religious beliefs and practices of the first pharaoh; or those of
the stone masons who worked on Notre Dame; or, say, the mask-
makers of Nigeria? Is the premised assumption of the pro-viewer
argument flagrantly false with respect to a vast historic and geo-
graphic span? It would seem so.

But it is surely not a silly or wrongheaded view; not least
because the list of its proponents includes the renowned novelist-
philosopher Leo Tolstoy, but because one hears, in virtually every
gallery and/or museum nasty criticism of Modernist art[10] for hav-
ing failed to conform to it.[11] We should like readers to recall that,
according to Tolstoy's conception, art is a transmission of feelings,
ideally of religious feelings, and that it somehow connects with
John Milton's practice as a poet. Although Milton never tried to
accommodate his readers, his alleged aim was to bring the reader
closer to God—and not to produce pleasure. For Milton the act of
reading was an act of religious *perception*. In this respect his
poetry is an instance of the True Art Tolstoy is after. For those
who get beyond the stage of finding Milton forbidding, reading
him will, or should, become an experience of sharing his feelings
of humility and his concern that we become more Christ-like.

One need not rest the case solely on the words of Tolstoy and
an interpretation of Milton's poetic practice. There is much to say
in its favor. The mosaic-makers who decorated the walls of
Byzantine churches and/or cathedrals might well be thought to
have been intent on telling the stories of Holy Scripture to the
faithful; so, too, the patrons of the painters who decorated the
walls of early Renaissance public structures;[12] most likely also the
sculptors or stonemasons who decorated the porticoes of the great
Gothic cathedrals, such as Chartres and Notre Dame.[13] It has
been argued, by Clement Greenberg, for example, that the
nineteenth-century French painters were the first willfully to dis-
regard the maxim that art's purpose is to teach or inculcate re-
ligious belief, to rouse enthusiasm for a cause, to rally patriotic
zeal, to inspire moral virtue. The argument is, therefore, well
taken, even if, as we have indicated, it errs by virtue of being
dressed as an unqualified or unrestricted truth.

Let us turn next to the opposing stand, which says, in effect,

that art is gratuitous,[14] a gift,[15] "purpose without a purpose."[16] Our first response is favorable, and not only because it has been supported by illustrious philosophers as diverse as Stuart Hampshire and Immanuel Kant, but principally because it rings true of our own experiences. Some words of caution and/or clarification are in order.

We were not around in 1907 when, according to Barbara Rose, the following was happening in New York City:

> While Henri and his "Black Gang" in their successful putsch against the National Academy exalted the primacy of life over art, the aesthetic revolution that marks the beginning of American modernism was gathering force under the aegis of art for art's sake.[17]

The gang's leader was Alfred Stieglitz, whom many regard as the one person responsible for bringing Modernism to the United States. At any rate, that's how it looked to Lewis Mumford, who said:

> In 1908 Mr. Alfred Stieglitz showed Maurer's new work at "291," and at that moment American art began to move at right angles to its previous course.[18]

Although this may be an exaggeration of sorts, some, like Duncan Phillips[19] seem to agree. Sasha Newman quotes Phillips as saying:

> Stieglitz wanted to establish a community of artists, writers, and critics who knew and understood radical European painting and to provide an atmosphere that would enable a uniquely American form of expression to assert itself. He was searching for an "idea" that would be expressed in terms of its native content.[20]

We cite these passages to highlight a dramatic moment in the American history of the arts, and to help clarify our position, for had we been around during those years we, too, might have felt the shock wave. Since this is the art on which contemporary students have been nurtured, the shocking new idea that a painting might, like Mozart's chamber music, not be "about" anything in the world, but "pure," as they used to say, is second nature to us. We do not walk around museums or galleries expecting in-

struction or edification as our grandparents might have. We go because we enjoy the experience and, sometimes, somewhat smugly, because we delight in admiring what is admirable. That is why it is easy for us, as it might not have been for our forebears, to accept the proposition that art is, or can be, for art's own sake.[21] We know that artworks can seem to exist entirely for their own sakes and can seem to have been created without any ulterior motive, out of sheer love and commitment to the process of artistic creativity in hope of adding to the wealth of fine art. Unlike other proponents of "our" view, we also know that it was not always that way.

NOTES

1. In the interest of stylistic nicety, we shall refrain from being explicit about our intention to refer to women, as well as men, in each sentence in which a reference is made to men and women. We shall, instead, use the standard masculine form, hoping our readers understand what is intended.

2. Arnold Hauser, *The Social History of Art*, translated by Stanley Godman (New York: Vintage Books, 1951).

3. See "Some Questions in Esthetics," in *Transformations*, by Roger Fry (New York: Doubleday, 1965), pp. 1-57. In this essay Fry contests I. A. Richards's reasons for concluding that there is no difference in kind, but only in degree, between the experiences one has while walking to the museum or the gallery, and the ones one has when attending to a picture or a painting inside. We go along with Fry, while not denying that it is possible to adopt an aesthetic attitude toward anything whatsoever, including mud puddles and broken window panes. Philosophers other than Richards have objected to Fry's thesis. We take the liberty of not considering them here.

4. We realize that in emphasizing delight we invite objections, in particular objections based on the capacity of great tragedies to arouse strong negative emotions: the horror and pity one may feel at *King Lear*, *Macbeth*, or Kurosawa's *Ran*, for example. Our excuse or explanation will have to be that we make no claim to provide an exhaustive characterization of aesthetic, as distinct from non-aesthetic, experiences.

5. We are not oblivious to the fact that, when the chips are down, virtually all Western philosophers of distinction have taken the same art form as the subject of inquiry. There are exceptions to that rule, not-

form as the subject of inquiry. There are exceptions to that rule, notably, Friedrich Nietzsche; but, on the whole, the history goes as we say it does. Seeing simply has been the most talked about of the sensory modalities.

6. David Hume, "Of the Standard of Taste," in *Hume's Ethical Writings* edited by Alasdair McIntyre (London: Collier Books, 1965), pp. 275-295. The passages we cite are on pages 279-286. We have chosen to bypass the criticisms Hume invites, especially on account of his notion that the imagination is to be calibrated, as though it were a delicate measuring device. We also leave aside, for the nonce, Kant's astute critique in his *Critique of Aesthetic Judgement*. There is neither world enough nor time. We do, however, wish to point out that, of Kant's "Four Moments of the Judgement of Taste," two deal directly with the conditions that must be met if one is to be an ideal "judge" of a thing's beauty; and two others with what we have called "factors not within his control." That is to say, we took Kant as our point of departure. See *Kant's Critique of Aesthetic Judgement*, translated by James Creed Meredith (Oxford: Clarendon Press, 1911).

7. James Wolcott, "A Scorecard for the All-American Literary All-Star Game," *Vanity Fair* (June 1985): 14-16. We recommend reading this essay with a great many grains of salt.

8. See *The Muses Flee Hitler*, edited by Jarrell C. Jackman and Carla M. Borden (Washington, D.C.: Smithsonian Institution Press, 1983). This book also documents Hitler's fear of non-Nazi art and the steps he took to ensure its removal from the Reich.

9. Kant, p. 80.

10. Here, once again, we rely on Clement Greenberg's nomenclature, as first set out by him in his essay "Modernist Painting," included in *The New Art: A Critical Anthology*, edited by Gregory Battcock (New York: Dutton, 1966), pp. 100-110. Also see Clement Greenberg, *Art and Culture* (Boston: Beacon Press, 1961).

11. See Leo Tolstoy, *What is Art?* translated by Aylmer Maude (London: Oxford University Press, 1930). Although criticisms of Tolstoy's extremist "communication theory" of art are as plentiful as blueberries on Cape Cod, its impact is very much alive.

12. We learned this from Michael Baxandall, though we suspect he would not deem even the patrons' motives so pure. See Michael Baxandall, *Painting and Experience in Fifteenth-Century Italy* (Oxford: Oxford University Press, 1972).

13. If Michael Fried is right, the same holds for the nineteenth-century painter, Courbet. See Michael Fried, "The Structure of Beholding in Courbet's 'Burial at Ornans'." *Critical Inquiry* 9, no. 4 (June 1983): 635-683.

14. Stuart Hampshire, "Logic and Appreciation," in *Art and Philos-*

ophy, edited by William E. Kennick (New York: St. Martin's Press, 1964), pp. 579-585.

15. See Lewis Hyde, *The Gift* (New York: Vintage, 1979).

16. Kant, p. 80.

17. Barbara Rose, *American Art since 1900: A Critical History* (New York: Praeger, 1967), p. 18.

18. *The New Yorker*, (November 9, 1930).

19. Sasha M. Newman, *Arthur Dove and Duncan Phillips, Artist and Patron* (Washington, D.C.: Phillips Collection; New York: Braziller, 1981), p. 12.

20. See Maria Quillard's essay on Minimalist sculpture (chapter 4 of this volume) for our considered opinion of statements like the one cited from Phillips here.

21. We recognize that in this paper we address two sets of issues— one concerning viewer characteristics, and one concerning the nature of art—and that we may not leave the reader feeling entirely clear as to the connection between them. (One might ask, for example, does "art for art's sake" mean that the viewer does not count at all? We do not think so, but we have not pursued the hows and whys of this particular path.) We apologize for any possible confusion, and rest our explanation for the somewhat elusive character of the discussion on a claim we can state but not fully explicate. The claim is that these two sets of issues are inextricably bound up with one another.

Three

A Discussion of Linda Nochlin's Essay, "Why Have There Been No Great Women Artists?"

Elizabeth Alford and Ingrid Stadler

Why are there no great women artists? Linda Nochlin offers an answer to this question in her article titled "Why Have There Been No Great Women Artists?" originally published in *ARTnews*. Many women and students of art history, finding this essay eye-opening, having never posed the question for themselves, tried to answer it, or even thought about what would constitute a satisfactory answer.[1] Not that the question ought to want much settling. The theory that the standard histories of Western art (and literature) were written by various hands, and pieced together during the centuries by various editors without reference to women is not one that is easy to treat respectfully. Although Nochlin subscribes to it, it does not rest on the well established case of any one poem or painting seemingly constructed by a man but actually constructed by a woman: neither art history nor literature furnishes us with a poem or painting whose genesis is known to have been such that we are asked to foist upon it the notion that historians or critics were ignorant of masterpieces created by women. Nochlin's position is founded on a supposition as to when the materials and tools for writing or for making works of visual art first became available to women, which has long since been shown to be untenable. In this essay we try to show that Nochlin's case rests on a base that has been cut out from under it, and that it is sustained by arguments that are of a character incapable of leading anyone to adopt her conclusions.

The following pages will, we hope, suggest a lesson of another kind: the sharpness of this lesson may be a more helpful service than the establishment of the points we have set ourselves to prove.

How can a distinguished art historian be expected to tolerate a theory so subversive of all that she has advocated for many years?[2] If we are right (and our theory affects art-historical questions about the genesis of masterpieces of Western art nearly as much as it does Nochlin's thesis), she has invested a reputation for sagacity in a stock of questionable value.[3]

As for our contention that there have been women painters and writers who deserve to be called "great," Nochlin may tell us that we have not even established a prima facie case for our opinion. Of course we have not. It was Bentley who first did this when he said that the *Iliad* was written for men,[4] and the *Odyssey* was written for women. Samuel Butler tacked down the final nail when he denied that the *Odyssey* was written for women, and that the depiction of Nausicaa, reproduced as the Frontispiece of his *The Authoress of the Odyssey*, was made for women. He maintained, instead, that the *Odyssey* was written by a young woman who doubtless had friends or acquaintances as dedicated to their chosen art as she was to her own.[5]

I

Before criticizing Nochlin's 1973 publication and its 1979 follow-up, "Towards a Juster Vision,"[6] we should recount her argument. Nochlin's answer to her question regarding the dearth of great women artists is premised on the assumption that no women's names merit inclusion in the pantheon of great artists. "The faults [for this state of affairs]," she writes, "lie in our institutions and our education,"[7] not in ourselves. Her delphic conclusion is that: "disadvantage may indeed be an excuse; it is not, however, an intellectual position."[8] By this we suppose she means to underline the philosophical maxim that excuses may coincide with shared beliefs or opinions, but not necessarily with valid reasons. A conclusion with a similar ring ends the later essay: "If we don't know what is true . . . we cannot achieve what is just."[9] The misconception with which she charges art historians, critics, gallery

owners, and museum curators is a theory she terms the "myth of the Great Artist" and dubs "the golden nugget theory of genius."[10] In the later essay she principally faults two kinds of injustice that must still be righted for the "implementation of justice": the injustice of being denied jobs and, more importantly, the injustice of women being treated differently on all levels of the societal structure.

We are disappointed that Nochlin has not published an addendum to her 1973 essay. If she wished to say anything against what appeared in *Art and Sexual Politics* (or in *Feminist Collage*), she has had ample time to do so. Had we been in her place, we should have thought it incumbent to do so; we find her silence eloquent on our behalf.

The steps that are supposed to lead from Nochlin's premises to her 1973 conclusions proceed as follows:[11]

(1) To date, "feminist critiques" of the discipline of art history have failed to "pierce [the] cultural-ideological" biases and inadequacies that color the conventions and practices of historical scholarship or critical review. Nochlin sees it this way:

> The feminist's first reaction [to the question: "Why have there been no great women artists?"] is to swallow the bait and attempt to answer the question as it is put: to dig up examples of insufficiently appreciated women artists . . . to rehabilitate modest . . . careers; to "rediscover" flower painters or David-followers; . . . to demonstrate that Berthe Morisot was really less dependent upon Manet than one had been led to think. . . .[12]

Nochlin faults this version of the "feminist critique" for conceding too much. An attempt to revalue or reassess neglected women painters merely reinforces the negative implications of the opening question: that women have produced works less beautiful, less elegant or eloquent or sublime than works produced by men. (Philosophers would cry "fallacy of many questions," meaning that these "feminists" should have realized that what Nochlin terms "swallowing the bait" is every bit as useful as offering a straight answer to the question, "When did you stop beating your grandmother?")

Although Nochlin makes it clear that such an admission of having been second-rate does not go far enough, she unfortunately

does not see or say that the next question is: If women artists have been responsible for artworks that are less beautiful, less elegant, and so on, than works by men, then why? Will Nochlin's "institutional explanation" suffice? Conceivably, for the nonce.

Nochlin then turns to another "feminist" approach that appears more promising: the idea that there is actually a different quality or kind of greatness for women's art than for men's:

> [Many contemporary feminists] propose the existence of a distinctive and recognizable feminine style, differing in both formal and expressive qualities from that of men artists and posited on the unique character of women's situation and experience.[13]

Conceding that art produced by women "intent on bodying forth a group consciousness of feminine experience might be stylistically identifiable as feminist, if not feminine, art,"[14] she nevertheless dismisses this stratagem, asserting that

> [in] every instance, women artists and writers would seem to be closer to other [male] artists and writers of their own period and outlook than they are to each other.[15]

Nochlin finds evidence of this synchronic relationship "in every instance" and avers that no "essence of femininity" shows up in a diachronic review of paintings created by women.[16] Her diagnosis of the appeal to feminists of believing that something like such an "essence of femininity" is discernible in women's paintings is that it is rooted in a congenial misconception of what art is, namely: "a translation of personal life into visual terms." But, she retorts, "art is almost never that; great art certainly never."[17] After dismissing this Tolstoyan idea as naive and unwarranted,[18] Nochlin proceeds to build up her own position.

(2) The second step is, therefore, the first step in the construction of Nochlin's stance on the position of women in the history of the visual arts. She reiterates that "the fault [for the low status of women] lies not in our stars, our hormones, our menstrual cycles . . . but in our institutions and our education."[19]

The fact is that there have been no great women artists, so far as

we know, although there have been many interesting and good ones who have not been sufficiently appreciated.[20]

In speaking here of the interesting and good women artists who have not been sufficiently appreciated, we assume Nochlin is not merely reiterating what she has already said, but setting the stage for her constructive argument. If this is so, her comment is presumably intended to emphasize that some women artists have been better than second-rate. Commenting that, although this state of affairs is regrettable, no manipulation of the historical or critical evidence will alter the situation, Nochlin brightens the story a little. "The miracle" is that

> given the overwhelming odds against women . . . so many . . . have managed to achieve so much excellence . . . in those baili-wicks of . . . masculine prerogative like science, politics, or the arts.
>
> . . . While there may never have been any great women com-posers, there have been great women singers; if no female Shake-speares, there have been Rachels, Bernhardts, and Duses. . . . And, in some of the performing arts, such as ballet, women have [even] exercised a near monopoly on greatness.[21]

We should, therefore, draw some comfort from the historical record. There is, at least, a history of great women performers (and of great scientists and political leaders as well?). We shall return to this point later.

(3) Nochlin's next, and more interesting step, requires de-bunking the art historian's uncritical reliance on a premise that she terms the "myth of the Great Artist." She summarizes this myth as follows:

> [It is the] fairy tale of the Boy Wonder, discovered by an older artist or discerning patron, often in the guise of a lowly shepherd boy, [which] has been a stock-in-trade of artistic mythology ever since Vasari immortalized the young Giotto, discovered by the great Cimabue while the lad was drawing sheep on a stone while guarding his flocks.[22]

In the footnote appended to this passage Nochlin notes that "a comparison with the parallel myth for women, the Cinderella story, is revealing," for Cinderella gains higher status on the basis of a passive, "sex-object" attribute—small feet—whereas "the Boy Wonder always proves himself through active accomplishment."[23]

In debunking this myth of boy wonders,[24] Nochlin makes use of an art-historical fact revealed by Nikolaus Pevsner in his discussion of the French Academy in the seventeenth and eighteenth centuries: that the transmission of the profession from father to son was considered a matter of course (as it was with the Coypels, the Coustous, the Van Loos, and others). She adds:

> In the rank of major artists, the names of Holbein, Duerer, Raphael, and Bernini immediately spring to mind; even in more rebellious recent times, one can cite Picasso and Braque. . . .[25]

Nochlin evidently wishes to imply that a parallel ontogeny helps explain the (modest) successes of women painters: having the right genes or role models is a necessary precondition for success by women as well as men.[26] We can accept that, and do for the time being.

(4) In order to "approach our question from a more reasonable standpoint,"[27] Nochlin proposes limiting the timeframe of the history of Western art encompassed by her study to that period extending from the beginning of the Renaissance until the end of the nineteenth century; and to restrict her focus to life-drawing from the nude, generally male, model which was "central to the training programs of academies of art since their inception."[28] The thrust of this segment of the overall argument is to establish that, by barring women from courses in life-drawing, the academies effectively debarred women from gaining acceptance as professional painters. If "credentialism" was as significant then as it is now, Nochlin's hypothesis would seem to be directly on target.

The discussion of the effect on aspiring women painters of being deprived access to "the ultimate state of training" closes with this observation:

> It also becomes apparent why women were able to compete on

far more equal terms with men . . . in literature. While art-making has traditionally demanded the learning of specific techniques and skills—in a certain sequence, in an institutional setting . . . as well as familiarity with a specific vocabulary of iconography and motifs—the same is by no means true for the poet or novelist.[29]

This point is strengthened by our knowledge of the careers of such notable authors as Jane Austin, Emily Dickinson, Sylvia Plath, George Sand, and Virginia Woolf, for example.[30] To round out this section, Nochlin adds some comments about "the fringe requirements for major artists" to which women were also not privy: the exchange of ideas with members of humanist circles, the establishment of suitable relationships with patrons, and the like.[31]

(5) The penultimate step of Nochlin's argument concentrates on nineteenth-century rules of etiquette, which vitiated the "propriety" of women (now "ladies") aspiring to great artist status. The single-mindedness and commitment demanded of a chef d'ecole were deemed unladylike, unseemly. Nochlin cites Mrs. Ellis's mid-century publication, *The Family Monitor and Domestic Guide*, widely read in England and the United States, which warned against the snare of trying too hard to excel at any one thing:

> To be able to do a great many things tolerably well, is of infinitely more value to a woman than to be able to excel in any one. . . . By being apt, and tolerably well skilled in every thing, she may fall into any situation in life with dignity and ease—by devoting her time to excellence in one, she may remain incapable of every other. . . .[32]

Nochlin also quotes Mrs. Ellis as saying that painting, or especially drawing, has one immediate advantage for the young lady over music: it is quiet and disturbs no one; in addition, "it is, of all other occupations, the one most calculated to keep the mind from brooding upon self, and to maintain that general cheerfulness which is a part of social and domestic duty. . . . It can also," she adds, "be laid down and resumed, as circumstance or inclination may direct, and that without any serious loss."[33]

Here again we concur with the implicit thesis that it was difficult, at best, to be both a lady and a committed artist in Victorian England. But we should like to know why Nochlin supposes that this factor is directly relevant to the position she espouses. As far as we know, France, and not England, was the hotbed of artistic creativity during the Victorian decades.

II

Although we have already indicated some of our reservations about Nochlin's argument, we need to make these remonstrations explicit. The faults found in Nochlin's premises doubtless stem from the biases built into the profession of being an historian specializing in the art of Western societies: e.g., her conviction that the only proper artists are persons who have the credentials one earns by attending an art academy or university. This strikes us as exceedingly odd, however, since we know, and should have expected her to know, that many of the greatest Western artists nurtured their skills, as well as their spirits and imaginative flair, in the workshops to which they were apprenticed—especially in the workshops of artists who had already achieved great acclaim. Take Leonardo, for example, and his apprenticeship in Verrocchio's atelier; or Signorelli, who evidently found his wings without stepping foot into any institution we would call an academy. Nochlin's slip is exacerbated by another flaw: she fails to consider Greek mythology. In this instance the stories about Icarus and Daedalus might have helped, for these were artists whose feats were surely accomplished without the benefit of attending an art academy on Mt. Olympus.

Granted that both Leonardo and Signorelli (but neither Icarus nor Daedalus) flourished during the historical period to which Nochlin restricts her focus, and granted that she believes Vasari's "golden nugget theory" of artistic genius dominated art criticism and theory in the Renaissance, we find it unfortunate that she fails to mention (our) opposing theory, which relies not on "nuggets" but on apprenticeship training.[34] We deem this regrettable because her failure to consider alternative views casts a shadow on her own.

We are also somewhat dismayed that Nochlin merely mentions Sappho in passing, for although we have no knowledge about the poet of Lesbos' gifts for painting, we would be reassured to find a more prominent discussion of her place among the great women poets or poetesses. It would also be reassuring to find some reference to Corinna, the Boetian poet (or poetess) whom Pindar was criticized a long time ago for neglecting:

> In [Pindar's] earliest poem he is said to have neglected the use of myths. This neglect was pointed out by the Boetian poetess, Corinna; whereupon Pindar went to the opposite extreme, and crowded his next composition with a large number of mythological allusions.[35]

Corinna is not the only Greek Lady Murasaki[36] of the eleventh century B.C.[37] There were other major women poets. Perhaps Nochlin is right in saying that there have been "no female Shakespeares"; we are simply not confident that she has marshalled sufficient evidence.[38]

A second fault is Nochlin's apparent readiness to discount the possibility that mothers or daughters might have crafted or created works that merit the accolade "art." Is this because the institutions in which Nochlin trained, at the time she trained in them, eschewed studies in folk art or domestic art? We suspect so. We do not, however, deem this a legitimate excuse for overlooking these areas entirely.[39] It is disappointing as well that Nochlin has not published an addendum: in this instance because folk art and domestic art have been legitimized since the 1970s.

Nochlin is careful to point out that beliefs about, and attitudes toward, women and daughters in traditional Western societies—in particular, the belief that wives belong in the home performing the tasks of motherhood attended by daughters who assist in the performance of housewifely chores—precluded the possibility of women becoming great artists.[40] By Nochlin's lights, these beliefs, rather than intrinsic feminine traits, are responsible for the status of women painters through the end of the nineteenth century. Our problem is that we find Nochlin guilty of the same charges she levels against other art historians: unconsciously retaining the golden nugget "mythology" of artistic achievement while asserting that it is nonsense. Nochlin accepts this theory insofar as she buys into the classificatory scheme of traditional male historians in se-

lecting the "great masters" of art. How can one believe both that artistic geniuses are "discovered" (and it so happens that geniuses have been discovered among simple shepherds rather than among simple shepherdesses) and also believe that societal pressures make or break the emergence of talents and reputations?[41]

We are troubled, however, by Nochlin's comparison of what she calls "the fairy tale of the Boy Wonder" to its alleged parallel myth for women, the Cinderella story. Why does Nochlin opt for the familiar version of the Cinderella myth rather than the mythology spun around Athena or Minerva, for example? Neither Athena nor Minerva has come down to us as "passive" or as gaining higher status on the basis of "sex-object" attributes. The obvious explanation does not seem good enough: that Cinderella allows Nochlin to make her point about female passivity. We are all liable to cite favorable precedent, but there are times to draw the line.

The first somber assumption of Nochlin's 1973 essay is that thousands of women artists have been forgotten. The second is that she continues to be of the opinion that "while there may have been no great women composers, there have been great women singers; if no female Shakespeares, there have been Rachels, Bernhardts, and Duses."[42] She evidently persists in the belief that women are less likely to be great innovators or the greatest (and sometimes last) masters of a particular style, like Bach and Mozart, or Rembrandt as portraitist for example.

Disputing the notion of innate genius in "Towards a Juster Vision," Nochlin reports that she has seen the virtuosic paintings done by Picasso at the age of twelve in the Barcelona museum, and that she has seen paintings created by members of a Brooklyn museum class for talented children that she deems as good as young Picasso's. Her point seems to sound an unduly deterministic note: the comparison she draws between Picasso's youthful work and the creations of exceptionally talented Brooklyn youngsters suggests that she believes individuals are infinitely malleable by their environment. But then she reminds us that Holbein, Duerer, Raphael, Bernini, Picasso, and Braque had fathers or grandfathers who were artistic and that the few women who achieved some success, such as Marietta Tintoretto and Mary Cassatt had fathers or mentors who were artists. What exactly is she telling us: is it the Tintoretto and Cassatt genes, or is it paternal encouragement? Nochlin's determinism seems to combine heredi-

ty and environment. The see-sawing in "Towards a Juster Vision" keeps time with that found in "Why Have There Been No Great Women Artists?" The bleak outlook persists.

Thomas B. Hess articulates an opposing viewpoint in "Great Women Artists."[43] He argues that women artists have produced art of the same caliber as that produced by men. To support his thesis he cites the cases of several women who studied with great masters and succeeded in creating works that were mistaken for the works created by the "master." Here are some examples. When Isaac Dudley Fletcher bought a David portrait of Mlle. Charlotte d'Ognes in 1917, he paid $200,000 for it (a sum generally believed to be the equivalent of two million dollars in 1985). He subsequently bequeathed the portrait to the Metropolitan Museum of New York. Quite recently, Professor Charles Sterling proved that the painting was the work of Constance-Marie Charpentier, one of David's students. Other examples include the painting of the jolly toper, attributed to Frans Hals, until it was discovered to be the work of Judith Leyster, a Hals follower; and the portrait of Marco dei Vescovi, presumably by Tintoretto, which was in fact painted by Tintoretto's daughter, Marietta.[44]

Though Hess's argument is interesting, it seems to buttress Nochlin's point rather than refute it. That women can paint as well as their masters is immaterial. Imitation does not amount to innovation. The pertinent question is whether women have been creative geniuses, leaders rather than followers. Our point is that, while there may indeed be women whose names should be inscribed in the pantheon of great Western painters, neither Nochlin nor Hess have provided the grounds for this position.

NOTES

1. Linda Nochlin, "Why Have There Been No Great Women Artists?" in *Art and Sexual Politics*, edited by Thomas B. Hess and Elizabeth C. Baker (New York: Macmillan, 1973), p. 1-42. (Revised version of essay originally published in *ARTnews* 69 (January 1971): 22-39, 67-71.

2. It may help to be explicit about Nochlin's interests. She has published major texts on Realism as well as Impressionism and Post-Im-

pressionism. Her specialty is Courbet. That is, she writes, virtually exclusively, about the history of painting and painters in Western societies.

3. Unfortunately the stock in which she has invested apparently attracted many, most notably Ernst Kris who is widely regarded as the foremost authority on this subject. The argument of his chapter "Approaches to Art," in *Psychoanalytic Explorations in Art*, seems innocuous enough, and in effect reappears in Nochlin's essay. Kris writes:

> The structure of the problem which exists while the artist is creating, the historical circumstances in the development of art itself which limit some of his work, determine in one way or another his modes of expression and thus constitute the stuff with which he struggles in creation. (p. 15)

We readily concur in the sentiment that historical circumstances "limit some of his work. . . . determine . . . his modes of expression. . . ." We feel quite differently about his chapter "On Inspiration," however. Even though Kris here admits that he "can speak only of men" (p. 301), he proceeds to contrast "inspiration with ecstasy" as the states nearest to inspiration and writes that

> In ecstasy the process results in an emotional climax only; in states of inspiration it leads to active elaboration and creation. (p. 302)

In view of the footnote Kris appended to this passage it is safe to surmise that he is committed to the thesis that women are, by nature, incapable of creating artworks of excellence. The footnote reads: "ecstasy seems more frequent among women, inspiration among men." Although a Kris follower might take refuge in his use of the locution "seems more frequent," we fault him for failing to heed the acknowledged limits of his competence. See Ernst Kris, *Psychoanalytic Explorations in Art* (New York: International University Press, 1965).

4. In this connection Simone Weil's book about *The Iliad* is also of interest. Simone Weil, *The Iliad or The Poem of Force*, translated by Mary McCarthy (Wallingford, Penn.: Pendle Hill, 1956).

5. Samuel Butler, *The Authoress of the Odyssey* (Chicago: The University of Chicago Press, 1967). We thank Dr. Ken Kaplan for the inspiration to draw on Samuel Butler's genius. Thanks to Ken, Butler has—spoof or not—become an invaluable guide. Butler's citation of Bentley is on page 4; his frontispiece is taken from a photograph of a work in the museum at Cortona called *La Musa Polinna*. It is on slate and burnt and is believed to be Greek, presumably of about the Christian era. Butler titles it *Nausicaa*.

6. Linda Nochlin, "Towards a Juster Vision," in *Feminist Collage,* edited by Judy Loeb (New York: Teacher's College Press, 1979), pp. 3-13.

7. Nochlin, 1973, p. 6.

8. Ibid., p. 37.

9. Ibid., p. 45.

10. Ibid., pp. 7-8.

11. Please notice that the order of our presentation follows Nochlin's. We shall not pause to consider whether this order of presentation should be the order of proof.

12. Ibid., pp. 2-3.

13. Ibid., p. 3. The term *style,* as is well known, comes from the Latin *stilus,* a writing instrument. Its crucial transformation for the subsequent development of the descendant idea is metonymic. See David Summers's "Conventions in the History of Art," *New Literary History* 13, no. 1 (Autumn 1981): 103-127. As Summers indicates, there are other etymologies of this term, e.g., George Kubler's, E. H. Gombrich's, and others. We would return to this matter of "style" in the context of mentioning a distinctive "feminine style," if there were world enough and time. As things stand, we rest content with the handling of the issue in chapter 2. That is, we do not inquire whether the idea of a feminine style collides with the idea of artistic style used by art historians or critics.

14. Nochlin, 1973, pp. 3-4.

15. Ibid., p. 4. We cannot help wishing that Nochlin had offered some explanation of the evidence she weighed in formulating this sweeping generalization.

16. A definition of "essence of femininity" would be illuminating.

17. Ibid., pp. 4-5. We shall return to this step in Nochlin's argument below.

18. This allusion to Tolstoy is ours. See *Leo Tolstoy, What is Art?* translated by Aylmer Maude (Indianapolis, Ind.: The Library of Liberal Arts, 1960). If Nochlin were to accept our supplement, this would not make her the first to charge Tolstoy with naivete.

19. Nochlin, 1973, pp. 5-6.

20. Ibid., p. 5. No doubt this "fact" should be self-evident, but we wish we knew Nochlin's criteria for determining "great" and "interesting and good."

21. Ibid., p. 6.

22. Ibid., p. 7.

23. Ibid., note 5., p. 38. We shall return to this move as well. We suggest that Nochlin read the original *Cinderella.* She may be astonished to discover that the girl is the primary agent in the story. See

Grimm's Fairy Tales, edited by Louis Untermeyer, Vol. 1 (New York: The Heritage Press, 1962), pp. 246-254.

24. We confess to firsthand ignorance of these myths, although we understand that they are stock-in-trade among professional art historians. As we had heard and known it, the "Divine Inspiration" theory to be found in Plato traces back to the nine Muses, all women as it happens. In Classical Greek mythology, the Muses inspire human artists: women as well as men.

25. Nochlin, 1973, p. 9.

26. See ibid, p. 16.

27. Ibid., p. 24.

28. Ibid.

29. Ibid., pp. 26-27.

30. Nochlin does mention these writers, although in a different context. Ibid., p. 4.

31. Ibid., p. 27. It is a little puzzling, however, that Nochlin mentions the patronage of Marie-Antoinette in explaining painter Elisabeth Vigee-Lebrun's "immense following at the French court." Ibid., p. 20. Marie-Antoinette would seem to be the sort of patron Nochlin thinks "suitable" for an aspiring painter.

32. Ibid., p. 28.

33. Ibid., p. 29.

34. Nochlin might have found support for the theory she favors in *Kant's Critique of Aesthetic Judgement,* translated by James Creed Meredith (Oxford: Clarendon Press, 1911), esp. #46-50.

35. *The Odes of Pindar, including the Principal Fragments,* translated and edited by John Sandys (Cambridge, Mass.: Harvard University Press, The Loeb Classical Library). Fragment 29 (5). "Pindar is also said to have subsequently defeated the poetess Myrtis, who was reproached by Corinna for competing with Pindar," *id.,* Corinna, Fragment 21. There were at least two poetesses who let Pindar know of their existence in Thebes, Miletus, Salamis, etc. We thank Professor Ria Stavrides for this information. It helps by confirming our suggestion that Nochlin's research may have been spotty. A look at the article "Sappho," in Smith's *Dictionary of Classical Biography,* would do so as well. See Butler, ibid., pp. 10-12.

36. The Japanese authoress of "The Tale of Genji" in the eleventh century A.D.

37. Butler, pp. 12-13. Butler claims that the authoress of the *Odyssey* flourished in the eleventh century B.C.

38. Question: How many *male* Shakespeares have there been? We come up with only one.

39. This is a plaint that should end, "to the best of our knowledge."

Nochlin 1979 might have contained the addendum we seek, but it does not. Nor do other essays known to us that were published after Nochlin's essay first appeared in 1971: "Some Women Realists, Part One," *Arts Magazine* 48, no. 5 (February 1974): 46-51 and "Return to Order," *Art in America* (September 1981): 74-83. The former seemed to hold the promise of an addendum, but says nothing that constitutes the sort of statement we were hoping to find. We will cite another relevant essay included in Hess and Baker's *Art and Sexual Politics* (1973).

40. Ibid., p. 8.

41. Compare p. 26 and p. 7 of Nochlin, 1973.

42. Ibid., p. 6.

43. Thomas B. Hess and Elizabeth C. Baker, *Art and Sexual Politics*. (New York: Macmillan, 1973), pp. 44-54.

44. Ibid., p. 45.

Four

The Art of Judd, Morris, and Smith
Homage to Contemporary Art (in which the
public sees absolutely nothing . . .
because it was never meant to)[1]

Maria Quillard and Ingrid Stadler

If one wishes to seek out the greatest American sculpture of the twentieth century, one is virtually forced to raise two central questions.[2] Who is the greatest sculptor, and need this artist be the creator of the greatest work? Which is the greatest school of twentieth-century sculpture? The answers we offer in this essay will, indirectly, tell a good deal about what we hope to get from a work of art. They should also tell why Tom Wolfe's caustic comments about Minimalist sculpture, in his 1984 essay for *Harper's*, are unwarranted, as are Robert Hughes's uncomplimentary conclusions in his 1981 work titled *The Shock of the New* (though the case Hughes makes for one of them is persuasive, even if unlikely to prove valid or sound).[3]

Art critics Clement Greenberg and Michael Fried judge that the Minimalist (Modernist) school or style of sculpture, created in the period from the end of World War II to the end of U.S. involvement in Vietnam, surpasses all other styles or schools of approximately a century of Western abstract art and, in particular, that the Minimalist works of Donald Judd, Robert Morris, and David Smith are masterpieces of Minimalism.[4] One aim of this essay is to explain why we concur: why these works are extraordinarily fascinating, having a complexity that makes the viewer want to take a long contemplative second look. We also find that

these works enhance appreciation of the aims and aspirations of a tradition of constructed sculpture, the emergence of which Fried, following Greenberg, traces to the Russian Constructivists, who flourished around the turn of this century (Naum Gabo, Vladimir Tatlin, and El Lissitzky, for example).[5] In view of the debate about the weight or significance of the American component, as distinct from the Continental Constructivist component, introduced into the history of abstract art by the masters of Minimalism,[6] a second aim of this essay is to shed light on this controversy.[7] Two of the parties in this debate clearly regard Judd, Morris, and Smith as creative innovators in the best sense, responsible for introducing an effective (because focused) historic transformation in modern artistic thought and practice. It remains unclear, however, where the third party (represented here mainly by Rosalind Krauss) stands. Given the parameters of this essay, we cannot do more than indicate the outlines of these three positions.

I. The Modernist Stance of Greenberg and Fried

Michael Fried evidently admires Donald Judd the theorist as highly as he does Donald Judd the sculptor, citing a passage written by Judd that he interprets as follows:

> Painting is seen here [by Judd] as an art on the verge of exhaustion. . . . The use of shaped rather than rectangular supports can, from the literalist point of view, merely prolong the agony. The obvious response is to give up working on a single plane in favor of three dimensions [which is precisely what Judd has done].[8]

Fried continues, averring that it would be wrong to suppose that "[a]ctual space is intrinsically more powerful and specific than paint on a flat surface," implying that the sculpture of Judd, Morris, and Smith is more powerful by being more powerful than other objects of roughly the same physical dimensions. Greenberg had spoken out earlier. He argued that "the new constructionsculpture begins to make itself felt as the most representative . . . visual art of our time" and that

> It is its physical independence, above all, that contributes to the new sculpture's status as the representative of modernism. . . . It

is for a self-sufficiency like sculpture's, and sculpture's alone, that both painting and architecture now strive.[9]

Strong praise from two highly influential critics[10] who have also commented on the importance of American painters of this generation. These critical assessments are not merely momentary matters in their careers as critics. Greenberg's eulogy first appeared in 1948;[11] Fried's essay was published in 1982. The latter underscores the Greenberg-Fried position by articulating their shared conception of the Modernist enterprise as an effort that is "in the service of aims and aspirations that have in view a new and profound and, for want of a better word, positive conception of the enterprise of painting." Fried also notes that he "would make the same sort of argument about the [implications of] . . . the use of industrial materials and techniques in Smith and Caro."[12]

Fried clearly finds in sculpture what he had found in painting: a new, profound, and positive conception of the enterprise. Greenberg had already brought his unleashed enthusiasm to the family of sculpture that traces its ancestry to the "engineering" feats of Constructivism. Greenberg sounds as convinced as Fried that, by the 1950s, Minimalist sculpture had achieved "the new . . . status as the representative visual art of modernism."[13]

The Greenberg-Fried position merits emphasis since it marks an advance over a prevailing negativistic construal of the important and seminal contribution made by these sculptors. John Perrault's "A Minimal Future? Union-Made"[14] represents the negativism that views Minimalism as a reductivist effort to exploit the possibilities inherent in the mediums chosen by these sculptors. According to Perrault, the Minimalist sculptors succeeded in reducing sculpture to its barest, quintessential nature: the creation of irreducible three-dimensional physical masses by eliminating (avoiding?) as many sculptural elements as possible (the pedestal, figurative forms, heavy or bulky materials, and others). This is fine as a start perhaps, and we agree that these sculptors abandoned the conventional conception of sculpture as continuous volumes. But why stop there, on the negative, reductivist foot? Why not indicate the positive ambitions of Minimalist sculpture? What would count as success or failure in achieving the aims unique to major sculptors of these decades? By what ideals were they inspired? What were their dreams or visions?

The intelligent sobriety of the Greenberg-Fried position enables it to sidestep or silence queries of this sort.[15] By tracing the lineage of Minimalist sculpture to Russian Constructivism at the turn of the century, the position relies, albeit implicitly, on the premise that Judd, Morris, and Smith represent a high-watermark in the evolution of (international) Western sculpture.[16]

The opening salvo of an opposing thesis is in Barbara Haskell's "Two Decades of American Sculpture,"[17] and another is sounded by Rosalind Krauss.[18] Haskell has evidently thought long and hard about the relationship of Minimalist sculpture to history and society, and arrived at a distinctive, somewhat startling, conclusion: these sculptors were involved in "a thoroughgoing attempt to sever all links to Western, mostly European, Artistic Traditions."[19] Krauss states that "the two characteristics of Modernist sculpture . . . declare its status, and therefore its meaning and function, as essentially nomadic."[20] That is, both Haskell and Krauss suggest that Minimalism is, or symbolizes, a dramatic revolt against, or break with, the (Western Continental) tradition—a tradition Krauss credits as the source of a tremendous production of sculpture during centuries of Western art.[21] Haskell, by emphasizing the unique American strand, distinguishes her perspective from that of Krauss, who seems to be saying that, like nomads, Minimalist sculptors are rootless—or "extraterritorial," to use George Steiner's term.[22]

II. The American Component

There are a number of ways to explain Haskell's satisfyingly patriotic construction emphasizing the American roots of Judd, Morris, and Smith's Minimalist sculpture. The most obvious is that there are few Star-Spangled-Banner-buffs among professional art or sculpture historians, and that it is good sport to heed the maxim that "the only way to rid oneself of a temptation is by yielding to it." In this instance, the temptation is to carve oneself a niche in the pantheon of fame and glory. This would mean fabricating a novel hypothesis and devising an argument for it.

Another, less cynical, explanation is that, by 1976, Haskell understood the rationale for mounting the 1970 exhibition of Robert Morris's work at the Whitney Museum of American Art. This

is not a farfetched assumption, considering the difficulty of the issues raised by these and other Minimalist works of the period. These issues concerning the very possibility that constructed sculpture, using industrial materials and techniques, and consisting of identical solids situated at identical spatial intervals from one another could even count as art—even as great or highly successful art. Robert Hughes, for example, who knows quite a lot about modern art, was probably not the first, nor is he likely to be the last, to dismiss the Robert Morris works in this exhibition as mere "logs and boxes."[23]

If there is comfort in numbers, the pro-Haskell defense might call John Russell to the stand. Russell would testify as follows:

> Between 1945 and 1970 there was acted out in New York City a considerable human adventure: the emergence after nearly 300 years of an independent, self-generating and specifically American art.[24]

Tallying votes does not, however, substitute for sound reasoning. Besides, in the definitive *Design In America: The Cranbrook Vision*,[25] where one might expect to find some word about these sculptors, there is none.

Far more interesting is a less obvious explanation for Haskell's conclusion that these Minimalist sculptors[26] intended to sever all links to non-American traditions, an endeavor Prudence Carlson denominates the denial of those (Continental) traditions' "outdated compositional relationships."[27] This explanation emphasizes that artworks like Donald Judd's *Untitled*—consisting of 21 units of stainless steel, each 4 by 27 by 23 inches, and, when installed, has overall dimensions of 4 by 236 by 108 inches—is more likely to give the impression of having been contrived in outer space than of being a masterpiece rooted in the tradition of Western sculpture since classical antiquity and through Auguste Rodin. According to this view, David Smith, the American sculptor, came first, but continued to incorporate stylistic traits borrowed from European Cubism. Claes Oldenburg and some others, who might be called "Pop Sculptors," came next, drawing on American images for inspiration. But the first real break awaited Donald Judd and Robert Morris, who lived and worked in America, making no use of either the old tradition of Western art, or the young Ameri-

can tradition with its reliance on anecdotal—or snapshot—images of American life. Judd and Morris discovered a new sense of order.[28]

According to Haskell,[29] the desire for clearly articulated, unambiguous structures is, as it were, built into the thought processes of American artists owing to their distinctive philosophical inheritance: American pragmatism.[30] She also maintains that the Minimalists' concern with large, inert, sculptural volume conforms with the art theories and practices of the 1960s, which inspired critics to discuss works of art in terms of medium rather than expressive power.[31] Furthermore, Haskell sees that a Greenbergian Modernist orientation exercised a significant influence on the development of all the arts in the twentieth century: significant, but overshadowed by the strand of American pragmatism. These indices of Haskell's familiarity with Modernist critical theory lend credence to her conclusion. As for her contention that the Modernist sensibility is evident in the sculpture of Judd, Morris, and Smith but is overshadowed by the influence exerted by their American roots, it may be true, as Haskell takes considerable pains to prove, that these artists were nourished by American pragmatism. But to characterize them as predominantly American seems to overstate the case. Call it philosophical or just a matter of style, but something more than a weighing up of the lessons to be learned from the Continental or International tradition versus the lessons to be learned from the American past seems to have separated the student in his library and the artist in his workshop.[32]

Carlson,[33] with her variation on the Haskellian theme, seems to stand on more solid ground, since Judd is himself expansive about his desire to break out of the stranglehold with which European thinking, particularly Cartesian Rationalistic thinking, has stifled art. There is also nothing Cartesian in these constructions; the logic that guided their construction is not readily evident. We shall return to Carlson and/or Judd in our final summing up.

III. Krauss and Archaeology

Krauss's "Tanktotem: Welded Images" opens with a flourish:

In 1950 David Smith constructed *Tanktotem I*. As it knifes across

one's line of sight, the sculpture's bladelike assemblage displays an almost aggressive flatness—an insistent planar quality which struck its first viewers with an immediate sense of strangeness.[34]

As the chapter unfolds it makes good on its implicit promise to compare and contrast Smith's achievement with works contemporaneous with Smith's own. Krauss compares *Tanktotem I* with David Hare's *Magician's Game* (1944), Isamu Noguchi's *Monument to Heroes* (1943), Jackson Pollock's painting *The Totem: Lesson II*, Anthony Caro's *Man Taking Off His Shirt* (1955-56), and others. The explanation for the way the text has been shaped is fairly obvious. It is dictated by the thesis that it is possible to trace the line twentieth-century sculpture has traversed from the traditional and figurative to the revolutionary conceptual art of the 1970s; that this art has developed a new "syntax" that discards "narrative" for instantaneous impact and boldly breaks new ground in the process. Along this line David Smith's *Tanktotem* is situated after Constructivism and Duchamp's "readymades," but before Sculptural Realism and the introduction of light, motion, and theatrical elements into sculpture by Francis Picabia, Alexander Calder, and others.[35] This makes good sense, and provides fine ammunition for anyone wishing to target Haskell's stand, since Krauss's line crisscrosses national boundaries and, *pace* Greenberg and Fried, moves from oil painting to sculpture, e.g., from sculptor Isamu Noguchi to painter Jackson Pollock and back again to sculptor Seymour Lipton.[36] Moreover, her comparisons are illuminating.

Everything that is interesting and provocative about *Passages* follows from Krauss's hypothesis that there is a rationale for the history of modern sculpture; and the enthusiasm she brings to her task compensates for the book's abstruseness. What is most impressive about *Passages*, the elegance of its organization, seems most in disrepair in Krauss's "Sculpture in the Expanded Field."[37] This appears in an anthology that offers, first of all, a survey of the roughly twenty-year history of earthworks and addresses some of the questions Post-modernism raises. As the dustjacket puts it:

Is it a concept or a practice . . . a matter of local style or a whole new period? . . . What are its forms, effect, place? . . . Are we truly beyond the modern, truly in (say) a postindustrial age?[38]

Surprisingly, there is little evidence of the stridency that usually afflicts this sort of project. Instead, individual contributors are given free rein to develop their ideas, and rarely leave one with the torpid feeling that they are simply covering obligatory ground. Krauss, for example, is free to ignore the questions the dustjacket mentions. In her case, the result is an essay that characterizes the domain of Post-modernist sculpture without venturing to say much about the effects of Post-modernism or whether we are truly in a postindustrial age, or what would count as answers to these broad questions.

One explanation for the conceptual drifting from author to author is that the essays comprising this collection are largely reprinted from other sources, though editor Hal Foster tells us that another contributing critic subscribes to Krauss's definition of Post-modernism as a break with the aesthetic field of Modernism. Learning that two out of nine share a language does help a little, as does Foster's observation that Krauss "details how the logic of modern sculpture led in the '60s to its own deconstruction—and to the deconstruction of the modern order of the arts."[39] The use to which Foster puts the term *deconstruct* points to an explanation of the construction of Krauss's essay.

The explanation Foster hints at is that the conception of "logic" central to Post-modernist thinking is not the conception of "logic" operative in Krauss's earlier essays in criticism. But this gives cold comfort to persons not already attuned to the "logic" of Michel Foucault's *The Archaeology of Knowledge*[40] or to the vocabulary of *October*.[41] Outsiders should, however, find it reassuring that Krauss believes that Modernism in sculpture began where others also say it begins, viz., with Auguste Rodin. She may also be right in contending that "two cases . . . bear the marks of their own transitional status," Rodin's *Gates of Hell* and his statue *Balzac*,[42] although calling these works "transitional" may be misleading.

Another complicating factor is that the earliest specific work Krauss needs to cite to develop the argument of her essay "Sculpture" is Robert Smithson's *First Mirror Displacement* (1969)—and in that year major Minimalist pieces were also making art historical news. (In "Sculpture" she is committed to the claim that Modernism died in the sixties or was then engaged in its own deconstruction. In *Passages* she makes the directly conflicting claim that

the Minimalist style of the sixties marks a logical phase in the evolution of Modernism.)[43] In short, Krauss affirms and denies the proposition that there is a "logic" or rationale for the succession of stylistic innovation in twentieth-century sculpture; affirms and denies that, say, David Smith builds on the achievements of Constructivism; relies on "historicism" in *Passages*, while dismissing "historicist" or quasi-Hegelian explanations in "Sculpture." If there are plums in Boolean algebra or Russellian logic (according to which a proposition and its contradiction cannot both be true) Krauss has effectively erased her contributions to art theory and criticism, liberating us from any obligation to take her work into account.[44]

IV. Concluding Comments

In view of the preceding section, our task boils down to weighing Greenberg-Fried against Haskell-Carlson, an internationalistic against a nationalistic interpretation of the importance or significance of Minimalist sculpture. Although we have alluded to our predeliction for the first, we have yet to confront the challenge of indicating the reasons for this weighting.

Although Judd allies himself with Greenberg and Fried on this issue, his remarks are sufficiently enigmatic to admit an interpretation that also aligns him with Haskell and Carlson. For example, consider the passage in which Judd speaks of breaking free from Cartesian thinking as a liberation of art from the principles of organization that result in so-called "relational painting." Judd writes:

> The qualities of European art are linked up with a philosophy—rationalism, rationalistic philosophy. All that art is based on systems built beforehand, a priori systems; they express a certain type of thinking and logic which is pretty much discredited now as a way of finding out what the world is like.[45]

Judd continues in this temper, commenting that were one to continue in the rationalist tradition one would be committed to heeding the heuristic principle that the elements of a work of visual art should stand in hierarchical relationships to one another; and to

adhering to a rule that admonishes artists to subordinate elements
of a construction to its dominating theme or concern: that the ar-
tist should balance and counterbalance the constituent elements
around the central one. Here Judd evidently thinks of himself as
committed to the project of burying the "classicist" or "linear"
heuristic,[46] which puts a premium on making the work legible for
a moderately responsive viewer. Judd evidently believes that
turning one's back on a conception implicit in the Western tradi-
tion of sculpture will break links that had chained sculptors' atti-
tudes, and values until the advent of Modernism.[47] So much for
the destructive or negative motif at the center of Judd's essay,
viz., that the practices of Modernism in the arts are in large part
intended to be practices of negation; more specifically, negation
of the historical continuity of Modernist sculpture with its prede-
cessor traditions of sculpting or constructing pieces for public
exhibition.[48]

Another principal thrust of the Minimalist criticism of the
Western tradition is to expose its "subjectivism" as a corpse in
wait of burial, and to fault it for failing to reflect or mirror the
world of twentieth-century philosophy and science. This mood
pervades an essay by Morris in which he (surprisingly) traces the
reductionist strategies of his work to Gestalt psychology:

> However certain forms do exist that, if they do not negate the
> numerous relative sensations of color to texture, scale to mass,
> etc., do not present clearly separated parts for these kinds of
> relations to be established in terms of shapes. Such are the simpler
> forms that create strong gestalt sensations.[49]

Is Morris recapitulating the truism that the mind can impose
or project a wholeness, unity, or form on an aggregate of units or
elements that would not be a complete "gestalt" or form but for
the activities of the human mind? Philosophers of a Kantian per-
suasion see this as part and parcel of man's capacity to acquire
knowledge of the world, to engage in "pattern recognition." They
smile when their peers stumble over problems, when those peers
endeavor to "simulate" the workings of the human mind and
discover that computers are not much good at recognizing or re-
identifying patterns.[50] Morris's thesis that we are capable of find-
ing such unity or wholeness in Judd's "stacks" or "wall progres-

sions" may be true, but would seem to trivialize Judd's achievement. As for the claim that the idea of capitalizing on such a mode of unifying an aggregate of distinguishable elements was introduced to sculpture around the turn of this century and marks a turn toward "antirationalism": it may be true that these works bewilder viewers who approach abstract sculpture with expectations of originality conditioned by their experience of Renaissance painting,[51] but "antirational" does not substitute for "bewildering": the former suggests attack on a fortress of rationality, the latter merely explains why something confuses or puzzles. In addition, to characterize the difference between, say, Michelangelo and Morris as a conflict between rationalism and antirationalism seems to overheat the atmosphere.

Carlson contrasts Minimalistic stratagems for achieving unity with those employed by the tradition available to sculptors since Michelangelo in saying that the wholeness or unity of a piece of Minimalist sculpture derives from the elements being "adjusted" to one another, whereas the unity of traditional sculpture is "created" out of the variety of its parts.[52] This way of stating the case may be informative, inasmuch as "adjusted" prepares for an enlightened approach to, say, Smith's pioneering efforts in welded sculpture, but to rely on ears attuned to such niceties of language seems to court disaster.

Hughes lends a helping hand when he reminds readers of the vogue for "combines," rather than "sculptures," in the mid-fifties.[53] Talk of "combines" conjures up images of midwestern farmlands, and this seems entirely in keeping with Hughes's claim that "one national legacy bore on [mid-century American art] and it came out of epic scale nature—American nature."[54] And Hughes could point out that Vincent Scully's voice echoes his own.[55]

Why remain skeptical, given this testimony for the "Star-Spangled-Banner" view of Minimalist art? We stick with the guns we shot earlier: tallying votes does not substitute for sound reasoning. And we find that the "internationalists" do this job better. We include William Tucker in this camp along with Clement Greenberg and Michael Fried. Consider first the contention set forth by Greenberg:

Nothing could be further from the authentic art of our time than the idea of a rupture of continuity. Art is, among other things,

continuity. Without the past of art, and without the need and compulsion to maintain past standards of excellence, such a thing as Modernist art would be impossible.[56]

And Tucker's view that

a sense of gravity . . . has been central to the most vital modern sculpture since Rodin,[57]

and that Rodin began

by reaching out for an as-yet undefined language of sculpture: which . . . he could define for himself only in the terms of the conventions . . . of nineteenth-century sculpture: the ambitions of Michelangelo and Donatello; . . . the Gothic carvers and recent French sculptors such as Barye and Rude.[58]

Greenberg may seem more emphatic than Tucker, but the latter's supporting evidence looks more compelling than the former's. This may be largely because Tucker gives the impression of having a wider range of historical art material at his command than Greenberg either has or lets on, or it may simply be a function of our being bowled over to learn that Tucker actually visited Tirgu Jiu in the southwest of Romania to decide for himself what gives some of Constantin Brancusi's sculptures their problematic character as public art: e.g., why *The Table of Silence* is a remarkable achievement but "an achievement of skill rather than of art," whereas *Gate of the Kiss* is "the true successor to Brancusi's first authentically modern sculpture" and why it and *Endless Column* work beautifully as public sculpture, though the latter is better still.[59]

Let us turn now to the first question posed at the outset. Our answer may not yet be clear. The greatest American sculptor? Let it be Smith, whom we are not alone in deeming to be surely enthroned as the leading American sculptor of his generation.[60] We asked whether he "need be the creator of the greatest work," to allow for the separation of artist from artwork. And this, we submit, would have been in order had we opted for someone other than Smith.[61]

We leave for another time the question of whether the American Minimalists subscribe to the proposition that the uneliminable

essence of Modernist sculpture is to transcend its sheer physicality, the physical reality of the units comprising the whole that is the piece of sculpture, that cannot be eliminated: i.e., their occupation of a position in space and time, their extension, mass, impenetrability, and so on. This is a question posed by Michael Fried's "Art and Objecthood" to which we refer in section I. Pursuing it would further complicate our complex ends.

Although Leonardo Da Vinci admonished good pupils to excel their masters, we rest with Greenberg's "Without the past of art . . . Modernist art would be impossible." That is, we rest with Tucker and Greenberg's position that the tradition of Western sculpture spreads its wings from the European to the American continent. There have been advances in the last several decades; our world has become larger, more encompassing.

NOTES

1. Thanks for help with the formulation of the title go to Tom Wolfe, in "The Worship of Art," *Harper's Magazine* (October 1984): 61-68.

2. In formulating our questions, we were helped by an article written by Lucie Smith: "The World's Greatest Paintings," in *The Illustrated London News* 273, no. 7044 (July 1986): 43-53.

3. The conclusion we are referring to is this: "The idea that fascism always preferred retrograde art is simply a myth." See Robert Hughes *The Shock of the New* (New York: Knopf, 1981). Henceforth S.N. Since Wolfe's critical platform seems to be, in this regard, virtually identical with Hughes's, we propose to treat them as twins for present purposes. We should, however, point out that, unlike Wolfe, Hughes acknowledges that he will not treat Judd, Morris, or Smith justly. He makes this acknowledgment in the "Introduction" to S.N. See also pp. 365-409.

See also Christopher Lehmann-Haupt's review of S.N. in the *New York Times* (February 9, 1981): C17.

Although the examples of Minimalist sculpture against which Wolfe directs his scathing remarks happen not to include works by the three sculptors we shall be discussing, it seems safe to assume that he would say about them what he says about the works he chooses to mention.

4. See Clement Greenberg's "The New Sculpture," in *Art and*

Culture (Boston: Beacon, 1961), pp. 139-145. Also, Michael Fried's "Art and Objecthood," in *Aesthetics: A Critical Anthology,* edited by George Dickie and Richard Scalafani (New York: St. Martin's Press, 1977), pp. 438-460. Fried prefers using the tag "modernist" for art that others, including Greenberg and Hughes, tag "minimalist." We opt for "minimalist" in this essay.

5. Michael Fried, "How Modernism Works: A Response to T. J. Clark," *Critical Inquiry* 9, no. 1 (September 1982): 217-234. Fried finds this tradition "culminating in Smith and Caro." We think we have grasped Fried's reasons for choosing these two sculptors. We know we have learned a great deal from reading and reflecting on his argument. Perhaps he will concur with our reasoning, and notice that we are not committed to the view that Judd and Morris represent the "culmination" of this tradition.

Clement Greenberg's "The New Sculpture" first appeared in 1948. See Greenberg's reference to this publication date in *Art and Culture.*

6. The question: How *American* is American art? is also taken up in chapter 7. But neither this essay nor the one on Jackson Pollock pursues the inquiry. One might, for example, wish to probe the significance of the use of mass-produced industrial materials by Judd and Morris.

7. For a quick summary of this issue see Hilton Kramer, "What Abstract Art Achieved," *The New York Times Magazine* (September 29, 1985). Kramer demarcates four forms of Modernist Abstraction: Expressionist, Surrealist, Geometric, and Constructivist. If one uses this schema, the controversy we address when we set out this essay's second objective would fit under the two rubrics "Geometric" and "Constructivist."

8. Fried, "Art and Objecthood," p. 439. The next citation is drawn from the same page.

9. Greenberg, pp. 144-145.

10. Wolfe offers a distinctive assessment of Greenberg's influence. He credits Greenberg with originally enunciating "the Turbulence Theorem which has been the article of faith . . . for the past forty years." Here is what Wolfe has to say:

> [The Turbulence Theorem . . . was enunciated when Greenberg said that all great contemporary art] "looks ugly at first." It was expanded upon by the art historian Leo Steinberg, who said that the great artists cause us "to abandon our most cherished values." In short, *if a great work of art troubles you, it's probably good; if you detest it, it's probably great.* (The emphasis is ours) Wolfe, p. 68.

11. See Greenberg, p. 145.

12. Fried, "How Modernism Works," p. 217.

13. Greenberg, p. 145.

14. John Perrault, "A Minimal Future? Union-Made," *Arts Magazine* 41, no. 5 (March 1967): 29ff. Perrault's reliance on formal analysis is understandable in view of the vogue of formalism in the sixties. Constraints of space force us to abandon the wish to question whether this approach is, by itself, competent to penetrate the illusion many of Smith's later works sustain. Compare, for example, Jonathan Silver, "The Classical Cubism of David Smith," *ARTnews* 82, no. 2 (February 1983): 100ff.

15. It does this because Greenberg et al. enable many to comprehend a trend in the develoment of the visual arts that invites perplexity. We welcome the helping hand, although we feel inclined to fault it for not going far enough. Our ideal position would, among other things, point out the mutual relations of Cubism and Surrealism, particularly in Smith's art.

16. We postpone discussing Rosalind Krauss's potential contribution to the Greenberg-Fried position. This potential idea is embedded in a portion of her *Passages in Modern Sculpture* (Cambridge, Mass.: MIT Press, 1981). Henceforth: *Passages*. It reads: "If Judd, a major practitioner of and spokesman for minimalism, was responsive to Chamberlain's work, this was because he saw in it the possibility for an entire realignment of sculptural practice" (p. 181). The John Chamberlain work in question is *Velvet White*, made of welded automobile metals, which is in the collection of The Whitney Museum of American Art in New York City.

17. Barbara Haskell, "Two Decades of American Sculpture," in *Two Hundred Years of American Sculpture*, edited by Tom Armstrong (Boston: Godine, 1976). Henceforth: *Haskell*.

18. Rosalind Krauss, "Sculpture in the Expanded Field," in *The Anti-Aesthetic*, edited by Hal Foster (Port Townsend, Wash.: Bay Press, 1983), pp. 31-42. Henceforth: "Sculpture." We shall have occasion to compare and contrast Krauss's position in this essay with the thesis she developed earlier in *Passages*.

19. *Haskell*, p. 198.

20. Ibid., p. 35.

21. Rosalind Krauss, "Sculpture," pp. 31-42.

22. George Steiner, *Extraterritorial: Papers on Literature and the Language Revolution* (New York: Atheneum, 1976).

23. Hughes, S. N., p. 379.

24. John Russell, "America Redefined," in *The Meanings of Modern Art* (New York: The Museum of Modern Art, 1974; Harper and Row, 1981). The defense loses some vitality when one discovers that Russell's position looks like Haskell's only at first glance, or from a distance. Russell's discussion of Judd, Morris, and Smith is found elsewhere in

the concluding chapter captioned "How Good is Modern Art?" where the theme of Americanism is not central. We shall have occasion to note that Hughes seems to side with John Russell in this matter. See Hughes, *S. N.*, ch. 6, "The View from the Edge," pp. 330-332.

25. *Design in America: The Cranbrook Vision,* edited by Robert J. Clark and Andrea P. A. Belloli (New York: Abrams, 1983).

26. We should wish to argue that a conclusion expressible in these terms is implicit in Jürgen Habermas's "Modernity—An Incomplete Project," translated by Seyla Ben-Habib, in *The Anti-Aesthetic,* edited by Hal Foster (Port Townsend, Wash.: Bay Press, 1983), pp. 5-13.

27. Prudence Carlson, "Donald Judd's Equivocal Objects," *Art in America* 72, no. 1 (January 1984): 114.

28. Notice that David Smith, one of our trio of American Minimalists, does not quite make it into the "All American" category. We shall return to the question of David Smith's work below, when we discuss Rosalind Krauss's position. But it is worth noting that when Krauss quotes Donald Judd's response to a query about the effect of John Chamberlain's 1962 *Velvet White,* she reports his saying "something about the volume exceeding the structure. . . . The structure sort of rattles around in this big space." In "Tanktotem: Welded Images," in Krauss's *Passages,* p. 181, Krauss construes this to mean that Chamberlain's work is "not supplied with a constructive rationale." We surmise she then regarded this as a plausible, though erroneous, charge against Smith.

29. *Haskell,* p. 198.

30. Curiously, Hughes also jumps on the "Star-Spangled-Banner" bandwagon, at least momentarily. For Hughes, the predominant influence is not American pragmatism, but American landscape. See Hughes, *S. N.,* not in his "The Future that Was" chapter (pp. 365-407) but in the penultimate chapter "Culture as Nature," pp. 324-364.

31. Op. cit.

32. We should be more explicit: we do not wish to be elusive. Our point is this: pragmatism teaches that to know a thing is to know how to use it, also that the only distinctions that count are the ones that are cashable in practice. The distinction we are supposed to draw between these artworks and other types of entities is not entirely cashable. These artworks have no use-value. They are, as chapter 2 argues, "entirely useless." Although similar conceptualizing may underlie the solution of the space-object relationships of Judd and Morris's work, we know of no evidence for concluding that either Judd or Morris were familiar with, or had strong leanings toward, American pragmatism such as that of John Dewey, William James, or C. I. Lewis.

33. Op. cit.

34. Krauss, *Passages.*

35. This is more or less how the backcover puts it. Another explanation of the book's principle of organization is that its concern "is the meaning, not the chronology, of sculpture since Rodin." By juxtaposing these explanatory hypotheses, the editors or publishers unfortunately introduce confusion rather than light. "Syntax" and "meaning" are not interchangeable concepts.

36. Ibid., pp. 150-154.

37 Op. cit.

38. Hal Foster, ed., *The Anti-Aesthetic* (Port Townsend, Wash.: Bay Press, 1983).

39. Ibid., p. xiii.

40. Michel Foucault, *The Archaeology of Knowledge*, translated by A. M. Sheridan Smith (New York: Harper and Row, 1972).

41. *October* is a quarterly started in the late seventies.

42. Krauss, "Sculpture," p. 35. Unfortunately, the penetrating study of Rodin's modernity in her earlier *Passages* is based on considerations that bear little, if any, relationship to the account in "Sculpture," and there is no reference to the earlier essay in the later one.

43. See *Passages*, pp. 161-165.

44. There are many obvious reasons for thinking this an unfortunate state of affairs. For present purposes one reason is that one does not know how to query details of Krauss's new position. How will she answer an objection to the interpretation of Brancusi's art in "Sculpture"? The essay makes him out to be an extraordinary instance of the way a sculpture's base or pedestal ceases to matter in Postmodernist art. But Brancusi uses much skill and invention in just this area. We agree that artists after Brancusi seem to regard base or pedestal as a mere matter of presentation, but take objection to Krauss's characterizing Brancusi in this way.

45. Judd as quoted by Bruce Glaser in "Questions to Stella and Judd," *ARTnews* (September 1966): 56-57.

46. It's not entirely fair to chide an American sculptor for being ignorant of the classic "linear" versus "painterly" dichotomy devised by Woelfflin in his memorable *Principles of Art History* (New York: Dover, 1942), translated by M. D. Hottinger. It may be thought still more egregious to fault him for not having familiarized himself with Nietzsche's polarities (the Apollonian versus the Dionesian). Unfair, perhaps, but unfortunate all the same. For, by virtue of his ignorance of these doctrines, Judd is led to draw an unsettlingly one-sided picture of "the tradition" and the grip from which he wants to escape.

47. Ibid., p. 56.

48. A more recent variant of Judd's thesis is T. J. Clark's "Clement Greenberg's Theory of Art," which appeared (with Fried's critical re-

78 Contemporary Art and Its Philosophical Problems

sponse, cited earlier) in *Critical Inquiry* 9, no. 1 (September 1982): 139-156. But Clark's position is even more extreme than Judd's, or the position ascribed to Judd by Glaser.

49. Robert Morris, "Notes on Sculpture," in *Minimal Art: A Critical Anthology*, edited by Gregory Battcock (New York: Dutton, 1968), pp. 225-226. The explanation of our use of the term *unsurprisingly* in this connection should become, if not entirely perspicuous, considerably clearer below.

50. A little philosophy goes a long way. We cannot resist the temptation to point out that the "new" problem that Morris struggles to resolve is as "new" as the philosophy of Immanuel Kant; that the problematic feature of making a whole of parts that are not given as parts of a whole is as old as Kant's argument with David Hume.

51. Yes, we mean Renaissance painting, not Renaissance sculpture. That is, we agree with the implications of the statement attributed to Greenberg in section II, viz., that painting has been the dominant art. Also, see William Tucker, *Early Modern Sculpture* (New York: Oxford, 1974).

52. Op. cit.

53. Hughes, pp. 334-335. It is worth noting that Hughes weighs in with an unlikely partner. In note 3 we took note of his alliance with Wolfe. We will see later why he seems to side with John Russell.

54. Ibid., p. 311.

55. Vincent Scully, "New World Visions," *American Art and the Metropolitan Museum*, Part II of a Public Broadcasting System series televised in 1985.

56. Clement Greenberg, "Modernist Painting" (1961), in *The New Art: A Critical Anthology*, edited by Gregory Battcock (New York: Dutton, 1966), p. 110.

57. Tucker, p. 145.

58. Ibid., p. 23.

59. Ibid., pp. 129-144. All the Brancusi-related citations are from the chapter "Brancusi at Tirgu Jiu." We share Tucker's particular affection for Brancusi, and his love for the four particular Brancusis he singles out as the artist's best.

60. See, for example, the unsigned review of an exhibition of Smith's sculpture in *New England Monthly* 2, no. 9 (September 1985).

61. We think this worth mentioning to silence Hughes, since he seems an untiring debunker of successful American artists, especially those who gained fame at an early age. He dubs each a "starlet" whom "one sees waddling about like a Strasbourg goose, his ego distended to gross proportions. . . ." Robert Hughes, "On Art and Money," *The New York Review of Books* (December 6, 1984): 20. To the best of our knowledge, David Smith made it the tough way and wore his fame and riches unspoiled.

Five

The Camera Observed

Kyra Reppen and Ingrid Stadler

"It is . . . obvious that this industry [photography,] by invading the territories of art, has become art's most mortal enemy. . . . If photography is allowed to supplement art in some of its functions, it will soon have supplanted or corrupted it altogether, thanks to the stupidity of the multitude which is its natural ally."

Charles Baudelaire in *The Salon of 1846:*
The Modern Public and Photography, 1975

"In photography, process reproduction can bring out those aspects of the original that are unattainable to the naked eye yet accessible to the lens. . . . And photographic reproduction, with the aid of certain processes . . . can capture images which escape natural vision. . . . Above all, technical reproduction enables the original to meet the beholder halfway . . . [enabling it] to be perceived in the studio of the lover of art."

Walter Benjamin in *The Work of Art*
in the Age of Mechanical Reproduction, 1964.

Berenice Abbott once remarked that she would rather people not ask her what type of camera she used, because she believes that the camera should not be a consideration when looking at her work.[1] It has been a continuing cause of irritation to serious photographers to be asked about their equipment or their film because they think that it is irrelevant. The art and/or skill lies in the eye of the photographer, not in his tools.

It is ironic that photographers accept this view, since it is on the grounds of being somehow mechanical—or "industrial," to use Baudelaire's term[2]—that photography continues to be dismissed from the bastion of high art[3] by some sober theorists and philosophers who look for what Roger Fry called "the signature of the artist" in a painting. Finding no such "signature" in photographs, they belittle photography. That this debate survives Walter Benjamin's scathing critique of its pertinence in "The Work of Art in the Age of Mechanical Reproduction"[4] must mean that it is an issue close enough to the heart of photographers not to be allowed to die quietly, for Benjamin made a compelling case for the position that, around 1900, photography had captured a place of its own in the domain of art. For Benjamin the question is no longer about the status of photography, but about the nature of its repercussions on art in its traditional forms. Put in other terms, one would have thought the debate squelched once Benjamin's work surfaced after World War II, but it continues. It is a highly visible instance of a type of argument caused by what philosophers call "the process/ product" ambiguity of the term *art*. And so Abbott's statement seems to raise an apparently vital issue: How do the process of making and the final product, the artifact, relate in our understanding of what exactly counts as art?

We should like to revive the thesis that the medium (tool or apparatus) is intrinsic to the final product, in photography as in other arts; and argue that in choosing one particular medium (one sort of camera rather than another) the photographer makes a decision that is, in principle, as significant as, say, Jackson Pollock's decision to employ fluid enamel and sticks, rather than oils and paintbrush or palette knife. The difference between photography and high art, we shall argue, seems to turn on the question of whether or not the photographer's exploitation of advances in technology[5] (and chemistry) should make one hesitate to classify photography alongside painting, etching, woodblock carving, and the like. In discussing the issue that seems pivotal we shall, however, emphasize one that we believe to be logically prior and the nub of uncertainty about photography's status: namely, unlike painting—the paradigmatic art form—which we regard as the enunciation of the visualizable, we take photography to be the disclosure of the visible.[6] Our thesis is that doubts about photography as high art are traceable to the error of approaching works

of the lens with expectations appropriate to paintings but not to photographs.

What about this medium, this mechanical contraption, the camera? Photography is a relative newcomer to the contenders for inclusion in the category of art. Its birth was contingent on advances in science and technology, as are its developments. The medium itself did not remain static. Photography is different for the 1980s than it was for the 1880s. In the first part of this essay we attempt to address the effect of different cameras on the photographer and on the idea of seeing and perceiving with a camera: the process of making a photograph.[7]

I

Berenice Abbott says we should not consider the type of camera in appreciating or assessing a photograph. To test the validity of her implicit contention that choice of camera is immaterial to a photographer's success in capturing the effects he wants to embody in his photographs, we experimented with five different camera formats and found that each one physically affected the way we approached our subjects. First, a summary of the history of the camera:

> The principle of the camera had long been known (as far back as the late Renaissance): light entering a minute hole in the wall of a darkened room forms on the opposite wall an inverted image of whatever lies outside.[8]

The "dark room" is the Camera Obscura, later made portable so that it could be put to use as a means for drawing a perfect copy of nature from an image formed from the light through a tiny hole in a box. During the eighteenth century this mechanical substitute for artistic skill flourished. The Camera Obscura was such a welcome novelty that it sparked the desire for a fixed image that would save the step of drawing, and make the pencil obsolete. Scientific research resulted in light-sensitive materials that could capture an image and, finally, to a method of fixing that image first on glass, then on paper. The need for other improvements followed: better lenses, greater conveniences, and portability. What does the history of photography, so closely

linked to the history of science, have to do with the way the photographer and camera interact?

The simplest camera is a light-tight (black) box with a small hole that can be covered easily. The homemade "pinhole camera" has no lens, no glass of any kind, no light meter: simply a hole for the aperture, a finger for the shutter, and a sheet of photo sensitive paper or film to record the image. With this camera the photographer does not frame the subject and then shoot the picture. There is no viewfinder. He or she points and shoots; and this camera, like any camera, photographs whatever is in front of it. The photographer can aim the box in the direction of the subject but cannot see what the actual frame will be. In this way a real distance is created between the eye and camera aperture, one that is absent where a viewfinder is involved. The camera, here, does not serve to connect the photographer with the world out there: there is at best a weak connection. This almost primitive technique of taking pictures results in not very sharp, often seemingly uncomposed, photographs, which are usually interesting. When approaching the subject, the photographer can have no sense of accuracy about the frame or what the resulting photograph/negative or positive will be or what it will show.

A slightly more advanced manufactured example is the box camera. Our Cyclone Sr. (c. 1888) works just like the pinhole camera except that there is a viewfinder that allows one to "previsualize" the fixed image. This camera has a working shutter but it is still a slow, one-photograph-at-a-time, bulky process, since it was originally intended for use with glass plates.

The 4 x 5 view camera is far more advanced with its adjustments for correcting and distorting perspectives of the subject photographed. There is a four-inch by five-inch ground glass for the photographer to look at (not through) and essentially compose an image by using the camera movements. The glass serves as a frame or "canvas," a two dimensional flattened view of the subject. The camera is heavy and uses plates, sheets of film, which make the process of selecting the time and place for taking a picture very slow. In this case the camera has a specific effect on the photographer, since the process of working with the camera's ground glass is so specific. The image appears reversed and upside down, so that the photographer, short of standing on his head, must be able to look first at the subject, then at the glass

visualizing the corrected image. Taking the 4 x 5 camera out for a walk is a slow, arduous, virtually intellectualized activity. Though the camera may "capture the moment," there is but little of the freedom of the snapshot camera. Weight and size serve to restrain acting on impulse: the photographer is, in effect, forced to think first and shoot afterward.

The 6cm. (film is 6cm. x 6cm.) medium format camera is, in many ways, a portable view camera. It lacks the adjustable movements of the view camera, but has the advantages of larger film and a ground glass for viewing. This camera is worn around the neck, on a strap, at waist level because the viewfinder is literally on top of the camera. The photographer, then, approaches the world by looking straight ahead and then down at a square, reversed image on ground glass, abstracted from the straight-ahead view. Having to look down is a challenge because, although the mirror reverses the image (left to right), the up-down reversal makes for a disorienting perception of what one is looking at.[9] The viewfinder is like a small ground glass that is used, like the 4 x 5, to compose the frame. The camera is portable: it relies on the body to function like a tripod if there is no available tripod: as the body moves or changes position, so does the camera's frame.

The 35mm. is the most portable, convenient camera—after the Instamatic. It is hand-held and almost entirely automatic. The viewfinder is smaller than the size of the film and is looked through (not at). The photographer holds the lightweight camera up to the eye and points. The image he sees is the image that will appear in the finished photograph. Given the format of the viewfinder, one points, shoots, and need not compose on the glass.

Camera type manifestly determines the photographer's approach to the world.[10] The camera distorts, disorients, frames, and flattens the three-dimensional world we inhabit. The size, type of viewfinder, possible adjustments, the simplicity of the pinhole, and the complexity of different lenses, the light meter, and the type of film are all constitutive of the camera's identity. Jonathan Bayer notes:

> The movement of the camera above or below normal eye-level alters the way the subject appears on the film surface. Lenses flatten spatial relations into patterns on the two-dimensional surface, the camera is placed so that key lines run into each other

fusing identity of forms, the subject is framed so as to illuminate ready indications as to space and scale.[11]

We incline in the direction Bayer suggests here: the type of camera selected determines the possibilities open to the photographer. We see it as the photographic counterpart of Heinrich Woelfflin's art-historial principle that "not everything is possible at every period" hence, that options available to Paul Cezanne were not options for a painter in Renaissance Florence or to painters in eighteenth-century France, and elsewhere. Recall that our thesis is that the medium determines the message; not that it is the sole determinant. In painting, the artist confronts a blank canvas, paint and brushes in hand. The use to which he puts his tools is a matter of his imagination and skill. Jacques Maritain puts it well when he observes that it is with the virtues "proper to prudence—perspicacity, circumspection, precaution, industry, boldness, shrewdness and guile—that the craftsmanship of the artist succeeds in engendering beauty."[12] This applies to photography as well. Following this line of reasoning, the salient difference between painting and photography is that the latter seems to depend on what the world is when there is no photographer looking at it in a way that painting does not. In this we concur with Walker Evans when he observed: "It is reality that photography reaches toward. The blind are not totally blind. Reality is not totally real."[13]

II

Some think that the photographer's dependence on, or reaching toward, reality clips his imagination's wings, making him significantly more dependent on the physical environment than either the painter or the sculptor, as we will see. It may be helpful to note that highly esteemed photographers make this very point in describing their own or their colleagues' procedures. One telling example is Edward Weston, who writes that "the photographer is forced to approach nature in a spirit of inquiry . . . with the desire to learn."[14] The photographer's eye is bent on learning something about nature, on discerning an arresting detail in his visible environment. On the face of it his is not a visualizing imagination,

more akin to the spirit of the inquisitive experimental scientist's than to the fabulist's or painter of nymphs or muses. One wants to say that "discovering" connects with photography; "creating," with painting. Unlike painters who learn as much from paintings as from close observation of nature, the photographer learns to do his looking outside the art museum or gallery: his place is in the city or the countryside. When painters struggle to acquire mastery of their technique, is there an obvious counterpart for the time photographers spend learning to adjust or optimize the relationship of eye to lens to subject? There does not seem to be. Nor would it ring true to say that advances in technology allow painters the kind of freedom that contemporary photographers enjoy, specifically the freedom to be as profligate in making studies or sketches as is the photographer, thanks to the development of the 35 mm. camera. More importantly, photography, as distinct from photojournalism, invites us to look again at our visible environment, to think about looking at the same sights or vistas under varying conditions—sunshine and haze, pre-dawn and dusk, springtime and autumn, among others. It does not invite us to contemplate life in a world more just than ours, or the behavior of persons endowed with virtues we ourselves do not possess. If such a broadening of our horizons is what it means to speak of the meaningfulness of great art, should we conclude that photography is devoid of meaning? Yes.

The photographer's aim is, typically, to show the world at the point of discovery. For that he needs to experience what Henri Cartier-Bresson once called the "decisive moment," i.e., the simultaneous "recognition of a fact and the . . . arrangement of the forms visually perceived"[15] so as to freeze that image for an audience. Experiencing such a decisive moment and capturing it on film requires an extraordinary astuteness or accuracy of perception—an ability to sense the atmosphere of the world out there, the visible relationships among persons or things, among textures and colors. The photographer approaches the everyday world with the heightened consciousness art lovers bring to their appreciation and contemplation of great art. The excitement we feel when we discover the quickening of our faculties (Kant's "quickening of the imagination and understanding") that is integral to experiencing an artistic masterpiece is kin to the excitement the photographer feels when he knows to click the shutter.

That sense of discovery when one gains a new insight, the infamous "ah-ha feeling," enables the photographer to feel sure of himself and the frame of reality he is about to fix. So the photographer ventures out, aware of the visible world around him, seeking a scene that strikes him as the stuff of a unique image, one that somehow challenges his perception of reality. If the function of art is the transfiguration of the commonplace, then it is the function of the photographer to perceive and record an image—an abstraction from the surroundings—that can serve to transform our perception of that reality.

Making a discovery is intrinsically tied to searching. E. H. Gombrich reminds us of Wittgenstein's teaching that all seeing is interpreting. He writes: "The world as we see it is a construct, slowly built up by every one of us in years of experimentation."[16] Unless we know ahead of time what we are looking for, we will not find it. (Compare searching for a book on the bookshelf and surveying a restaurant to find whether or not a friend is there. In the former instance, decorative objects on the shelf are effectively erased from view; in the latter, all unfamiliar faces, along with the furnishings and table settings.) When the photographer sets out with the camera, he is intent on looking for something. The salient difference between him and us in our study or at the doorway of the restaurant is his ability to spot subject matter worth depicting; not ours, to eliminate perceptible material irrelevant to the task at hand. Creative activity is marked by an attunement such as his. It would be right to say of the artist, but not of us, that he is in a state of readiness to be struck by something he-knows-not-what, an image that leaps to him uniquely. This is how his peculiar sensory apparatus wills his discovery into being. The readiness for the decisive moment, the tingle of his nerve endings will make him find the extraordinary amid the ordinary. His is an open-ended exploration or adventure.

Photographers characteristically think and talk about previsualization. They visualize the finished print when they photograph their subjects. Without their cameras, photographers tend to see things around them as photographs. Jacques Henri Lartigue,[17] one famed photographer, said that as a boy he would spin his head around with his eyes shut and blink them open as if to have his eyes and head serve as aperture and camera recording images in his mind. He could evidently make his mind function as

if it were a camera. It does not, however, mean that Lartigue was unable to perceive the world as do the rest of us. It can be truly said of all of us that, in an extended sense of "apparatus," we are "apparatus-bound," i.e., that we see what we are prepared to see and interpret the stimuli that accost us in terms of what we have learned, or have been conditioned, to expect. Our personal histories are histories of our routes through the world available to us, and what we perceive as well as how we perceive it at any moment is colored or informed by our earlier perceptions. In this sense our past experiences telescope into the present, influencing how we register or respond to the persons and things we encounter. A scene or event that startles, intrigues, or frightens one person may not catch another's attention. It is the photographer's role to alert us to aspects of the world of our common experience that, although there to be seen or experienced, would otherwise pass unnoticed, remaining in the background, rather than emerging into the foreground and becoming a focus of attention. In this way the photographer can extend the range of our experiences: can sensitize us to minutae, revitalize the pedestrian, dramatize the routine, color the drab, and so on. In these ways and others, he can contribute spice and excitement to things and happenings to which we have become deadened or inured.

A passage from Eugene Herrigel's *Zen in the Art of Archery* may be helpful:

> Even the simplest have got in a muddle. Is it "I" who draws the bow, or is it the bow which draws me into the highest state of tension? Do "I" hit the goal, or does the goal hit me? Is "it" spiritual when seen by the eyes of the spirit—or both or neither? Bow, arrow, goal and ego, all melt into one another, so that I can no longer separate them. And even the need to separate has gone. For as soon as I take the bow out and shoot, everything becomes so clear and straightforward and so ridiculously simple. . . .[18]

Replace "bow" with "camera" and the process of photographing becomes clearer.

The issue of the camera, that contraption without which no photograph could be born, makes it seem difficult to be specific about the relation of photography to the other arts. As we have seen, the problematic status of photography as art does not ultimately derive from the intrusion of an instrument dependent on

fairly advanced technology into the creative process. This is in part because there is, in principle, no difference between the shop-talk of photographers and that of artists working in other media. Yes, when photographers get together they talk about the latest developments in the camera equipment industry, whether lenses from Japan are as good as the old reliable German ones, and the like. They talk like technicians. They care about their techniques. How does that differ from what we have learned about Picasso, of whom it is said that when he got together with his friends they talked about where to get canvas and who sells the best? The root of the controversy, we have shown, is that viewers wrongly approach photography with expectations appropriate to painting. We therefore conclude that the disclosure of the visible is a viable if lesser achievement than the enunciation of the visualizable.

NOTES

1. Berenice Abbott, quoted by John Canaday in his "Introduction" for Hank O'Neal, *Berenice Abbott American Photographer* (New York: McGraw Hill, 1982). In view of the nuts and bolts commentary printed alongside the reproductions of Abbott's photographs, and that she designed and patented a good deal of scientific equipment, including two cameras, when working with the Physical Science Study Committee at the Massachusetts Institute of Technology, starting in 1958, we should perhaps have written "*Even* Berenice Abbott once remarked . . ." We chose not to, so as to emphasize the thrust of her arguments in her work titled *A Guide to Better Photography* (1941), cited by Canaday, op. cit., p. 20. In our judgment Abbott persisted in her conviction that "photography is a new vision of life, a profoundly realistic and objective view of the external world," making it more right than wrong to say that her work shows that she repudiated "arty and manipulated" photographs. She also commented that "greater realism [is] the *raison d'etre* of photography."

2. Charles Baudelaire, "The Salon of 1859: The Modern Public and Photography," in *Modern Art and Modernism: A Critical Anthology*, edited by Francis Frascani and Charles Harrison (New York: Harper & Row, 1982).

3. The high art/low art, avant-garde/kitsch, sort of distinction was

not invented by Clement Greenberg, but he added fuel to the contrast. We shall not continue to write "high art" when we mean to talk about the arts; nor, for similar reasons, "serious photographer" when we mean to talk about photographers. It should be evident that we do not mean "low art," "kitsch"—and that we do not include sometime-snapshooters among photographers.

4. Walter Benjamin, "The Work of Art in the Age of Mechanical Reproduction," in *Marxism and Art*, edited by Maynard Solomon (Detroit: Wayne State University Press, 1979).

5. Abbott would doubtless prefer that we write "science" rather than "technology," but "technology" is particularly apt for our purposes.

6. The distinction we wish to draw between the visualizable and the visible conforms with Berenice Abbott's as well as with Ansel Adams's insistence that their photography aspires to objectivity, striving to be ever more "faithful to the real appearance" of things, to use Abbott's terms. Abbott, cited by Canaday, op. cit., p. 21. See also, Ansel Adams, *Making a Photograph* (New York and London: Studio Publications, 1935), esp. p. 18. Even if this distinction does not survive close philosophical scrutiny, it should serve our purposes since it constitutes a first approximation that merits its own day in court.

7. Please notice that, for the purposes of this essay, what takes place in the darkroom—in the process of developing, cutting, printing— can, and will, remain on the back burner.

8. Beaumont Newhall, *The History of Photography from 1939 to the Present Day* (New York: Museum of Modern Art, 1949), p. 9.

9. We know that similar obstacles can fox an astronomer; the limitations of technology function as a limitation on the extent of human knowledge. A potentially interesting question for philosophy is whether such in-practice limitations do or do not have a bearing on the thrust of Kant's argument in the "Transcendental Aesthetic" of the *Critique of Pure Reason*. At this point it underscores our sense that Kant is confused about what his "Transcendental Aesthetic" succeeds in showing. "Underscores," because thinking about the third of Kant's three critiques, particularly the *Critique of Aesthetic Judgement*, while studying the "Transcendental Aesthetic," highlights the comment Kant makes in the first, about the reason there is no Kantian-type transcendental critique of the "aesthetic" aspect of cognition. Maybe it should merely make one wonder about what Kant would have said if he had carefully read the first critique after finishing the third.

10. Yes, it determines; it is not the sole determinant.

11. Jonathan Bayer, *Reading Photographs: Understanding the Aesthetics of Photography* (New York: Pantheon, 1977), p. 34.

12. Jacques Maritain, "Art as a Virtue of the Practical Intellect," in

Art and Philosophy, edited by William Kennick (New York: St. Martin's, 1964), pp. 62-77.

13. Walker Evans, cited in *Modern Culture and the Arts,* edited by James B. Hall and Barry Ulanov (New York: McGraw-Hill, 1972), p. 467. Henceforth *M. C.*

14. Edward Weston in *M. C.*, p. 494.

15. Cartier-Bresson in *M. C.*, p. 473.

16. Ernst H. Gombrich *Art and Illusion: Study in the Psychology of Pictorial Representation* (New York: Pantheon, 1960), p. 297.

17. Jacques Henri Lartigue, *Diary of a Century,* translated by Carla van Splunteren (New York: Viking, 1970), unpaginated. It isworth noting that the exploratory-kind-of-looking characteristic of Lartigue exemplifies the Wittgensteinian lesson about our dealing with visual ambiguity. See Gombrich, p. 5.

18. Eugene Herrigel, *Zen in the Art of Archery,* translated by R. F. C. Hull (New York: Vintage Books, 1971), pp. 69-70.

Six

do you want to remain seated?

Jennifer Garden and Ingrid Stadler

Performance Art is a loosely defined area of artistic exploration, i.e., the artistic counterpart of a scientific research program. It encompasses a wide range of activity involving an ever-widening variety of artists with diverse styles, methods, and concerns. Had we set ourselves the task of characterizing the ambitions of performance artists, we should have had to abandon hope of saying something instructive about the import and intention of this nontraditional school. Generalizations are suspect at this stage. At most, and incompletely, it may be possible to say that this group has thrived, as all Postmodernist art has, by treading on ground Modernism had ruled "off limits."[1] We propose to restrict our discussion of Performance Art to a few key issues that it introduces into traditional aesthetics. If at least one reader of this essay is, after reading it, impelled to forfeit one evening at the movies, or the theater or opera, to an evening that involves participation in a contemporary performance piece, it will have served its purpose.

"Performance," although without the contemporary nomenclature "performance art," has been a domain of artistic exploration for centuries. Gregory Battcock puts it grandly when he writes:

> Before man was aware of art he was aware of himself. Awareness of the person is, then, the first art. In performance art the figure of the artist is the tool for the art. It is the art.[2]

We say that Battcock puts it "grandly" since speculations

about the origins of art in the evolution of man strike us as grandiose. This is because we have no way of telling in advance what would count as evidence for or against such a proposition, and the capacity to do just that is a principal criterion for distinguishing propositions that carry cashable claims from others that may serve rhetorical (or poetic) purposes but not strictly cognitive ones. In succumbing to the temptation to trace the origins of performance art to the origins of human self-awareness or self-consciousness, Battcock's words are helpful, as rhetorical flourishes are. By overstating or overgeneralizing they in effect function as a heuristic: in our case, the heuristic that Performance Art is not as new as yesterday or yesteryear. Our supposition is that Performance Art was not born with the turn of the 1980s, in which it has become easy to trip off the tongue a four-syllable neologism: "post-modernist." Battcock has the courage to hypothesize that its roots penetrate phenomena that reach far back into human history. He also helps by reminding us that the performer's body and mind are the art. It matters little whether that performer performs in theatrical costume or in customary attire.[3]

A prevailing opinion is that Performance Art is most readily domesticated if viewed as an outgrowth of theater. We disagree, in part because salient features of the elusive creature tell against this genealogy, or, as Hume would put it, against "that species of common sense"[4] that accepts performance as an offspring of theater. The other "species of common sense" fasten on the salient differences between Performance Art and theater that keep the conventions of traditional Western theater alive.

Nowadays traditional theater has many facets: A playwright writes a script. A producer decides to back it, seeks out a director to orchestrate the production, and locates a theater to produce it in. Casting comes next. Actors are then assigned roles, instructed or cajoled to play those roles as the director understands them. The director's interpretation of the lines, sometimes checked against the playwright's, calls for decisions about staging. Once these choices are made, and the rehearsals are over, the play is presented to an audience: if opening night looks auspicious and the next morning's reviews are favorable, there is reason to expect a protracted run. If the run is as long as forecasted, the company and its director may be said to be acting in conformity with some unwritten rules about how many or few liberties with text and

stage directions individual members of the cast may take on their own.

By contrast, in Performance Art, the performing artist is both entirely in charge and entirely free to create variations on the spot. In working out the original idea, the artist may invite others to participate in the early stages of translating ideas into actions, and disinvite them from participating in the performance; or the artist may opt to create a troupe of helpmates, leaving each member of the collaborating troupe free to improvise. Sometimes the audience is, in effect, written into the text, i.e., expected to participate in the presentation; sometimes, the performer holds the audience captive. When a "performance" is staged or announced to happen, those who attend are warranted in inferring that the artist has had a hand in choosing the exhibition space, or in modifying the physical arrangements of the gallery, community house, church, or similar location where the performance(s) will take place. A serious performance artist is apt to modify the performance piece to accommodate changes in audience membership or changes in ambience.

Think of early, improvisational jazz bands, like Louis Armstrong and Lil Harden's *Red Hot Peppers* in New Orleans in the 1920s. These improvisational bands are analogues to performing art troupes of the 1980s. Think also of the jazz bands that have kept together for decades, asymptotically. Who is to say whether the performance of the Paul Smith Trio, which appeared with Ella Fitzgerald in the "Jazz at the Philharmonic in Tokyo" in 1983 is more consistent with its earlier self, (remembered for its "Jazz at the Philharmonic" series in the 1940s), than is performance artist Laurie Anderson in the mid-eighties with the little girl Laurie Anderson of approximately thirty years ago? The mere chronological differential is not likely to be decisive. (Recall the multidimensional Bach: composer, conductor, performer; performing while conducting a piece he recently composed to amuse his patron. With the wisdom of hindsight, we find an overall coherence).

At first blush it may look as though the lack of tradition of patronage is the crucial difference between Performance Art and traditional art, particularly traditional theater. Now, however, even this is changing. As early as 1979 Lee Quinones, a New York

graffiti writer who was "never mistaken for just another graffiti writer,"[5] had a show that was mounted by an Italian art dealer—first in New York City, then in Rome, and "had no trouble selling the work at $1,000 a canvas."[6] To muddy the waters yet more, Quinones established three other contacts with the "legitimate" art world: (1) an established gallery owner moved his gallery and himself to the South Bronx; (2) a collector from Park Avenue found an empty space on the posh Upper East Side, and dozens of large (graffiti) canvases appeared in it almost overnight; and (3) many aspiring young artists and graffiti writers got together for the first time in 1982 at The Times Square Show, which opened in an abandoned massage parlor on 41st Street.[7]

We shall not argue the close ties of these novel art forms to Performance Art, feeling no need for one. For, even given this "brotherhood" of Post-modernist Art, Performance Art remains elusive. With its tendency to challenge distinctions among art forms, to ignore conventional artistic disciplines, and to hoot at "good taste," Performance Art keeps critics guessing—if they are sufficiently interested in it to want to say or do anything with or about it. One explanation for the scanty critical attention given graffiti, for example—one we favor—is that graffiti art, when linked to break-dancing and rap music, becomes too trendy, too much like fashion to merit anything but a fashion-writer's attention.[8] Considered on its own, apart from these societal phenomena, Performance Art feels different, more like fairly stable art than fickle fashion. To the best of our knowledge, no reputable critic has yet traced the historical origins of Performance Art as an art form in its own right, weighing or sifting the data to which his or her own imagination and training have led. There have been starts in this direction, sufficiently many to substantiate the view toward which we incline. As we see it, the story begins in the Italian Renaissance.

Attanasio di Felice is one of the starters. He avers that the most significant prototypes of Performance Art are in the works of such seminal figures as Alberti, Leonardo DaVinci and Bernini. We like his argument, since it conforms with our prejudice that Performance Art has deep historical roots, even historians (and philosophers) of Western art have typically concentrated on the enduring physical entities of the Renaissance masters—their painting, sculpture, architecture, and so on—and allowed their Perform-

ance Art creations to remain in the shadows. This line of reasoning helps to explain why spectacles such as Leonardo's *Paradiso* are hardly ever mentioned: it is an instance of proto-performance. In *Paradiso* the performers were costumed as planets, and directed to revolve while reciting verses proclaiming the return of the Golden Age. (On the back streets of Florence a walking tourist can find the shop that continues to manufacture Commedia dell' Arte masks. A hint of discoveries in this artistic practice of making and/or producing short-lived performances? It would seem so.)

Di Felice quotes Alberti, author of the first Renaissance treatise on painting and systematic perspective (1435), as saying:

> The Platonic view, that the plastic arts represent a sort of frozen music or an artificial fixing of the universal flux, in respect to which performance, temporally providing temporary intervals, may be regarded as a nexus between the fluid and the fixed.[9]

If we accept this decidedly nontraditional reading as a plausible interpretation of "the Platonic view of art" and concur, for the nonce, with Alberti's premise that there is such a thing as "the" Platonic view, then we may conclude with him that the importance of performance lies in its giving form to, or informing, "intervals of the universal flux," if only temporarily, or for a time. This, in turn, suggests that performance links up with the Platonic doctrine of "division": "the a-temporal" and "the continuously changing," hence filling a sort of gap in the Platonic scheme.[10] And if all this is right, or on the right path, there has been a "space" for "performance art" for some 400 years of Western history.

Fortunately, "performance" has not suffered from its benign neglect, nor have painting and sculpture suffered in consequence of being pedestalled as the superior arts and associated with the Greek god Apollo, charioteer of the sun, marker of the lines of order in the known universe: the god of clarity and of the perfection achievable through rigorous exercise of the mental powers and strict self-discipline requisite for achieving mastery over one's chosen medium or media.[11] The arts of painting and sculpture continue to be revered as the "highest" of the High Arts—despite Aristotle's alternative conception of the comparative ranking of the various art forms—while the theater arts have generally been assigned to the second rung, held suspect on grounds of aiming to humor the hedonism lurking beneath man's skin.

Aristotle's *Poetics* leaps to mind, however, as a notable and influential counterargument. (Aristotle ranks theater, particularly tragedy, as the highest and most encompassing of the arts. Tragedy is the highest, because it alone is capable of effecting in the audience the "catharsis" that results from witnessing a drama. We are "cleansed," symbolically or literally, by experiencing the tragic wisdom achieved by the tragic hero: learning that, like the hero whom we pity, each of us is liable to great suffering like his; by empathizing with him, fearing his fear, learning also that even the greatest among us may err, as he does, by dint of undue pride, or undue confidence in our capability for great achievement. Though Oepidus solved The Riddle of the Sphynx, his doing so set in train a series of events that led to the tragic end, the moment in which, realizing what he had done and taking full responsibility for his act, Oedipus tears out his eyes.)

According to Rose Lee Goldberg, author of many books and essays on performance, the original director of theater of Weimar Germany's BAUHAUS wrestled heroically with the problem of integrating aesthetic theory with practice. Oskar Schlemmer's torments, she writes:

> . . . reflected a puritan ethic. He considered painting and drawing to be that aspect of his work which was most rigorously intellectual, while the unadulterated pleasure he obtained from his experiments in theater was, he wrote, constantly suspect for that reason. Although beset with doubts as to the specificity of the two media, theater and painting, Schlemmer did consider them as complementary activities. [In] his writing he clearly describes . . . "the dance as Dionesian and wholly emotional in origin . . . I struggle between two souls in my breast—one painting-oriented, or rather philosophical-artistic; the other theatrical; or to put it bluntly, an ethical soul and an aesthetic one."[12]

Another historical source or precedent for Performance Art would seem to be traceable through the history of a painter's presence in his paintings. We choose the Impressionists as our point of departure (although Michael Fried traces it further back, to Courbet[13]; and some other art historians trace it back to the Renaissance, to Leonardo, for example.) We choose the Impressionists because they are among the first Western painters who clearly painted for themselves or their friends rather than for an

official patron: church, state, prince, etc. We think it safe to say that they felt no need to camouflage their presence in their works.

In Impressionist painting, what Roger Fry called the "handwriting of the painter"[14] is palpably present: one can discern the artist as selector of the subject matter and as creator of the picture. One understands that the painter considers the pigments, the paint brush or palette knife, and opts to use some rather than others of those available. One is, or can be, sensible to the fact that, having chosen his subject, the artist probably needed to be close to the physical site in order to capture the look of a fleeting moment. One also knows that catching this moment required deviation from the conventional means of creating a representational painting. To depict a transient moment the artist had to exploit a medium that does not readily allow for virtually simultaneous capture.

In his later years the painter Paul Cezanne created works that count among the great achievements of Modernism. The thrust of the Modernist imperative (to which we made implicit reference earlier in our essay) was and is to cast out illustration, storytelling, the ugly or grotesque, and so on. Cezanne contributed by giving free reign to his desire to "dwell with his perceptions, steeping himself serenely in this world of the eye," as Meyer Schapiro expresses it.[15] He continues:

> But the visible world is not simply represented . . . it is re-created through strokes of color. . . . The whole presents itself to us on the one hand as an object-world that is colorful, varied, and harmonious, on the other hand as the minutely ordered creation of an observant, inventive mind intensely concerned with its own process.[16]

Schapiro is careful to point out that Cezanne "loosened the perspective system of traditional art,"[17] and that if he "gave up both the perspective system and the precise natural form, it was because he had a new conception of painting." Schapiro's single most important point for our present purposes is implicit in each of the sentences in which he writes, as if from within Cezanne, since his doing so attests to the truth of our claim regarding the gradual emergence of the painter in his works.

One can continue tracing the evolution of the painter's emergence in his two-dimensional canvas, noting the ways in which the

imagery becomes ever more reflective of his inner vision and how he seeks to make the inner vision manifest on the outer canvas. We pass through the Dadaists and Surrealists and their flirtation with the subconscious, embodying their dreams in their dream imagery. The canvas is by now no longer treated as a window on the natural world; it becomes, instead, a window into the imagination. With the advent of Abstract Expressionism in the 1940s it becomes clear that the visual arts are no longer concerned with mimetic images of the external physical world, but with the representation of the tumultuous world within. "It was with abstract expressionism that critics began consistently describing artists as performers and began grading them according to performance."[18]

If we single out Jackson Pollock and the notion of "Action Painting," we should conclude that "representation," in the traditional sense that traces back to the Greek "mimesis," has nearly become extinct. Line is no longer contour or boundary; it is line for line's sake, searching for its own end or beginning. Once Pollock abandons the traditional painter's tools, and turns to dripping paint from cans, then to using an airbrush, the frenzy or exuberance of Pollock's gestures becomes inescapable. He probably comes as close as anyone to transforming painting into performance.

As we did earlier, when we traced the origins of Performance Art to Renaissance performances, we have now traced its origins in the art of painting. In constructing these history charts we have been trying to make Performance Art look a little less bizarre than it might otherwise appear to be: we have not been, nor have we intended to be, arguing or maintaining that Performance Artists either do or would recognize themselves in our picture. Some among them would also deny that they turned to performance only when Modernist painting had exhausted its drive or efficacy. And some might even protest the proposal that they, in effect, echo the anti-art or anti-aesthetic manifestoes we associate with Futurism and Dada. Yet outsiders, like ourselves, find striking similarities, since Futurism as well as Dada explored performance as a means of rebelling against the traditional assumption that art is art only when the artistic process ends with an enduring physical entity as its product. They rebelled against the prevailing bourgeoisie's treatment of art objects as commodities. But Futurist and Dadaist performances were neither performances qua stage

performances, nor performances qua Performance Artists' performances. Their actions are more aptly characterizable as the actions of agents provocateurs, performed with the intention of offending or jolting those among their audience who fail to notice that art merely serves the interests of the elite few: the state of affairs attacked by Tolstoy in his famous essay "What is Art?"[19] Unlike Tolstoy's plea for a True Art that would conform with his "definition" that

> art is a human activity consisting of this, that one man consciously, by means of certain external signs, hands on to others feelings he has lived through, and that other people are infected by these feelings and also experience them[20]

the Futurists and Dadaists wanted an object-less art. For Tolstoy the hallmark of great art is its infectiousness; for Futurism and Dadaism, it is an undisciplined, not necessarily attractive cry. For Tolstoy the art object is the artist's means for joining with his fellow men in an exaltation of Christian virtue; for Futurism and Dadaism there is no object, and if any exaltation is forthcoming, it would seem to be an exaltation of license (as distinct from liberty and disciplined freedom). In most if not all of these respects performance art resembles Futurism and Dadaism. But unlike these predecessor schools (and in conformity with Tolstoy's dream), the audiences for performance art seek and get easy access to the art. One consequence might be the elimination of an interpreter, since the audience no longer needs a go-between: there is no mystique to dispel, no iconography to "read" or decipher. One other consequence falls to dealers and collectors, who have no business to transact here. These matters are elegantly summarized by Hugh Adams when he writes:

> the performance artist wishes people to see and feel what occurs during the course of an artistic creation rather than retrospectively view the process of reification, or gaze in artificial surroundings at the end product.[21]

In the opening paragraph of this essay we promised to discuss "a few key issues [Performance Art] introduces into traditional aesthetics." The time has come to be explicit about what they are. The list is not in order of importance, and the issues will not

be surprising, since they concern the topics addressed by traditional aesthetics, namely, questions about (1) the nature of art and (2) of its audience, (3) about the role of the artist in society, and (4) about the function(s) of the art critic. We shall be brief, since most of these issues have been implicitly contained in the foregoing pages.

(1) The principal question Performance Art raised about the nature of art is this. In periodically proclaiming that they have outwitted the art market by creating object-less art, are Performance Artists failing to realize that they have substituted themselves for the objects? They seem to be as sellable, as buyable, and as manipulable as more traditional art objects. Granted, they have succeeded in creating nonpermanent art; if there are longer-lived physical embodiments, they can be assumed to be written accounts of the idea(s) that inspired the artists(s), or visual documentation of the first or final presentation. Although some performing artists have expressed reservations about such documentation, realizing that it negates the immediacy of the audience's experience, it is neither clear nor obvious that the protestors speak (or spoke) for all.

One might also question the import of Performance Art as viewed by its creators and its audiences. If one believes—as some of us continue to do—that art's aim is in some form to edify as well as to delight, to offer new perspectives on ourselves and the world we inhabit, to present us with works of such mastery as we might wish to emulate and admire, then the questions multiply. From our vantage point it looks, at present, as though no answers are forthcoming, in large part owing to the performing artists' evident disdain for our values. (Should we strive to admire the rhythms of Vito Acconci's masturbations underneath a gallery floor? Is Joseph Beuys's demonstration of a four-day sit-in in a cordoned-off section of a gallery, where he and a wild coyote commune, a lesson in courage that we are simply not yet able to appreciate? The fault may lie in us and not in them. Is it time to choose?) The horizon is not, however, entirely problematic. The new nonlinearity, wit, and multi-media-mastery we relished in Robert Wilson's *Between the CIVIL warS* shows that innovation can be wonderful, and wonderfully funny. The hitch for the ambitions of performing art in this memorable event is that it appeals to a restricted few: to those of us who are insiders to his

jokes and familiar with the segment of human history Wilson makes use of. But that may be a matter of little moment. In any event, we have learned not to generalize. Our verdict is in on Wilson's *CIVIL warS*. That is all.

(2) The audience for which Performance Art is intended is everyone, as we indicated earlier. We readily grant that some performing artists have won instant celebrity of a kind that Modernist Art never won, and probably never will; yet we are not convinced that such instantaneous applause is to be awarded. No doubt the Modernist masterpieces on which we were weaned are difficult and demanding. Ezra Pound's "Cantos" are not for everyone; nor are the Cubist achievements of Braque and Picasso; nor, for that matter, are the string quartets of Elliott Carter. But is the needed antidote Julian Schnabel's studding of his canvases with pieces of broken china or the upside down images of Georg Baselitz? The artistry of Laurie Anderson and Robert Wilson have earned our admiration; we wonder about the rest.

(3) The multiple roles, functions, and/or responsibilities of artists seem to us to have been reduced to just one by this new breed of artists: when successful they offer high comedy, and in times like ours that may well be what's needed most. Whether that is all we need remains in question.

(4) That Performance Art means to eliminate critics and criticism should already be obvious; that it can get along without them seems not to be the case. In saying this we know we show our faggery, for unlike many, we thrive on critical assessment. The contemporary world does not. Is that too bad for us, or for them? Let our readers decide.

NOTES

1. "Modernist," as we use the term here, tags a body of work—painting, sculpture, architecture, dance, poetry—produced over the last one hundred years of Western art. We should explain that we wish to conform with the spirit of Clement Greenberg's essay, "Modernist Painting," and broaden the scope so as to include areas of major artistic achievement that Greenberg does not expressly address. See Green-

berg's "Modernist Painting," in *The New Art: A Critical Anthology*, edited by Gregory Battcock (New York: E.P. Dutton, 1966), pp. 100-110.

Second, we should explain that the task of characterizing what we here implicitly tag "post-modernist" seems to us even more difficult than the task of saying what art is. W. B. Gallie, among others, has warned that "art" is an "essentially contested concept," i.e., that it is always fair to attack (contest, challenge) a proffered definition. Immanuel Kant argued that point earlier when he introduced his distinction between "determinate" and "indeterminate" concepts in the "Introduction" to his *Critique of Aesthetic Judgement*. We do not think it necessary to freight our concern in this essay with its historical ancestry. We mention some of it here to indicate that our concern in the essay comes out of a tradition and out of knowledge, and out of our developing understanding of just where "performance art" stands or fits at this time. See Gallie's "Essentially Contested Concepts," in *The Importance of Language*, edited by Max Black (Englewood Cliffs, N.J.: Prentice-Hall, 1962), pp. 121-146; and Kant's *The Critique of Judgement*, translated by James Creed Meredith (Oxford: Clarendon, 1911, 1973).

Third, we should be explicit about this: The difficulties one encounters in trying to articulate anything about "performance art" simply feel to be of a different order of magnitude than the ones created for philosophers by traditional art forms.

2. Gregory Battcock, "L'Art Corporel," in the catalog *The Art of Performance* (Venice: Palazzo Grassi, 1979). Pages are not numbered.

3. Although we persistently speak of "the artist" and use the masculine form, we do not intend to create the erroneous impression that "performance artists" are invariably male, or invariably single. They come in all colors, shapes, and sizes; they are soloists or groupings of collaborative individuals. Nor is it entirely right to say that they use their bodies and minds: they do that, but they also use musical instruments—mostly, but not always, using traditional instruments in unorthodox ways, and/or using electronic synthesizers (i.e., nontraditional sorts of things) for their music-making.

4. See David Hume, "Of the Standard of Taste," in *Hume's Ethical Writings*, edited by Alasdair MacIntyre (New York: St. Martin's Press, 1984), p. 59.

5. Steven Hager, *Hip Hop* (New York: St. Martin's Press, 1984), p. 59.

6. Ibid., p. 63.

7. Ibid., pp. 64-65.

8. One notable exception is John Russell's "Art View" written for the "Arts and Leisure" section of *The New York Times* (Sunday, August 22, 1982). Russell writes with glowing warmth about Performance

Artist Laurie Anderson, that the songs she sang in her little girl's voice "were wisps and shards of sound and speech, as if she were the last person alive . . . and trying to remember how things had once been." She holds huge audiences captive, he says, "by touching a nerve that had not been touched before."

If "post-modernist" tags works that include architecture, it is hardly true to say, in 1985, that responsible critics pay no attention to "post-modernist works." The raucous voices one hears virtually every day when some mention is made of Robert Graves, Hans Hollein, et al. should settle the matter once and for all—provided the sheer number of voices and the intonation pattern of the voicings is not a surface phenomenon, but a harbinger of some sobriety, and some integrity of critical assessment. At this writing the jury is still out.

9. Attanasio di Felice, "Renaissance Performance: Notes on Proto-typical Artistic Actions in the Age of the Platonic Princes," in *The Art of Performance: A Critical Anthology*, edited by Gregory Battcock and Robert Nickas (New York: E. P. Dutton, 1984).

10. We rely here on the "theory of division" contained in the Platonic dialogue, *Theatetus*. Please notice that we are, in effect, playing an "if . . . but" game, as distinct from making a claim to genuine knowledge. We also offer this as our excuse should someone object that Leone Battista Alberti's reference is to Plotinus, not Plato. For the purposes of this essay, that does not matter. What does matter is our measure of success in making the point that, as far back as Alberti, the hard and fast line distinguishing between what Aristotle called "the arts of space" and "the arts of time" was beginning to give way; see Aristotle's *Poetics*.

11. We are aware of the oversimplistic character of our picture of Apollo. We think this is not the place to produce a finely hewn figure. Although we are also aware of a twitch caused by a decision to leave Friedrich Nietzsche to one side, we leave it to our readers to fill out the sketch and to find Nietzsche's "Birth of Tragedy out of the Spirit of Music." Notice the use to which he puts his distinction between "the Apollonian" and "the Dionesian" principles.

12. Rose Lee Goldberg, "Oskar Schlemmer's Performance Art," in *Artforum* (September 1977): 32.

13. See Michael Fried, "The Structure of Beholding in Courbet's 'Burial at Ornans'," *Critical Inquiry* 9, no. 4 (June 1983): 653-683; and "Representing Representation: On the Central Group in Courbet's 'Studio,'" *Art in America* 69, no. 7 (September 1981): 127-133, 168-173.

We know that other, earlier cases abound: Velasquez's *Meninas* is one striking case. We start in late nineteenth-century France for convenience, and because we believe we can make our case without exploring the entire history of Western painting.

14. Roger Fry, "Some Questions in Esthetics," in *Transformations* (New York: Doubleday Anchor, 1956).

15. Meyer Schapiro, *Paul Cezanne* (New York: Abrams, 1952), p. 9.

16. Ibid., p. 10.

17. Ibid., pp. 10 and 17.

18. Helen Kontoua, "From Performance to Painting," *Flash Art* 10 (February-March 1982): 17.

19. Leo N. Tolstoy, *What Is Art?* translated by Aylmer Maude (Indianapolis, Ind.: The Library of Liberal Art, 1960).

20. Ibid., p. 51.

21. Hugh Adams, "Against a Definitive Statement on British Performance Art," *Studio International* (July-August 1976): 7.

Seven

Jackson Pollock: America's Artistic Genius or a Product of His Time?

Anne Eu and Ingrid Stadler

A diverse agglomeration of voices harmonize in singing Jackson Pollock's praise: they join to sing that he is America's artistic genius of the twentieth century; some even hail him as America's artistic genius simpliciter. Our aim is not to challenge this assessment, but to explain it. To achieve this end we start by surveying the use to which the term *genius* is put in critical discourse about painting and the art of painting: why earning the accolade "genius" seems, but is not, equivalent to getting a three-star rating from Michelin.

I. Immanuel Kant

To the best of our knowledge, the philosopher Immanuel Kant was the first to introduce the concept "genius," as it is currently understood, into the vocabulary of philosophical aesthetics, art history, and criticism.[1] It was Kant's conviction that persons whom we can call artistic geniuses must demonstrate four or five distinguishable talents or capacities: imagination, understanding, soul, and taste *(Einbildungskraft, Verstand, Geist, Geschmack)*.[2] We say "four or five" factors to reflect an ambiguity in the text. The first four are taken from #50 of the *Critique of Aesthetic Judgement;* the possible fifth factor is from #49, where Kant speaks of the capacity to "present aesthetic ideas." It is not clear whether ascribing *Geist* to an artist or artwork implies this capacity or

adds another (distinguishable) element. We think Kenneth Clark offers an emendation of Kant's fifth condition.[3] He maintains that, in moments of particular enlightenment when there are sudden feelings of inspiration, great artists will create genuine masterpieces only if they are "deeply involved in the understanding of [their] fellow men."[4] As we will show, Clark's characterization pinpoints what is problematic in the claim that Jackson Pollock is a great painter capable of producing masterpieces: that his intellectual grasp, imaginative power, and technical skill combine to produce works of such calibre. But we wish to start with a discussion of Kant's philosophy in order to bring out the complexity of the central issue.

One of Kant's intellectual motivations for focusing attention on the elements ingredient in artistic genius was his desire to distinguish it from scientific genius. He also wanted to contrast "genius" with "taste," a capacity Kant defined as a "merely critical, not a productive faculty" (#48). Third, he meant to alert the reader to the basis for drawing an art/craft distinction (#43).[5] Philosophers call this procedure the delineation of a concept by constructing its contrastive set. The operative assumption in employing it is the belief that to succeed in locating the meaning of a target concept, one needs to state precisely how its meaning differs from the meanings of concepts with which it is easily confused or confounded.

What does it take to produce a masterpiece? Kant answers "genius" and avers that "genius is the innate mental aptitude (ingenium) through which nature gives the rule to art."[6] Does this mean that some have it and some do not? Are some just born with it, and the rest of us doomed from the start? Yes, though this oversimplifies. Rather like acorns dropped in the Sahara Desert or squirrels too lazy to squirrel acorns away, the "seed" of genius reaches fruition only on condition of being nurtured and cultivated. Here is Kant's deeper and more detailed four-part explanation:

(1) Genius is a talent for producing for which no definite rule can be given: not an aptitude like cleverness; . . . consequently originality must be its primary defining mark.

(2) Since there may also be original nonsense, [the products of a genius's efforts] must be . . . exemplary . . . [that is, they] must

serve to inspire others to learn how to realize their own ambi-
tions. . . . [They do this if they] function as yardsticks for aspiring
artists of successor generations: yardsticks against which to mea-
sure their own achievements if they then resolve to equal or
surpass their predecessors.

(3) [Artistic geniuses] cannot demonstrate how [they] contrive
their works, for [they] give the rule as nature. Geniuses do not
know how they arrived at their ideas, nor can they will such ideas
into existence. (Hence our term *Genie* is presumably derived from
genius, understood as the unique guardian, or guiding spirit given
a person at birth . . .).

(4) Through genius Nature prescribes the rule, not to science, but
to art, and this only if the art in question ranks as fine art.[7]

One last passage completes Kant's picture. It is located in a
section of *K.U.* devoted to the argument that "genius . . . is the
exemplary originality . . . [achieved by an artist's] free employ-
ment of his cognitive faculties."[8] This sounds a theme central to
Kant's analysis concerning the freedom with which understand-
ing and imagination interplay[9] in the creative process, and the
artist's autonomy in choosing among available options (i.e., ma-
terials, tools, and subjects available for artistic experimentation or
innovation in his world or time). One might say that Kant foresaw
that twentieth-century writers would use "academic art" as a pe-
jorative, referring to artworks that strike them as hidebound or
formula-like. But Kant did not link philosophy to prophesy, and
having no personal contact with institutions like the French or
British Academies, he could hardly have intended to cast asper-
sions on their curricula or expectations. His insights in this instance
were of an armchair nature, though this was not so with issues
pertaining to the sciences.

 K.U. is replete with discoveries. For example, on scrutinizing
the operations of the human imagination as it operates in art, he
concluded that the theory of imagination developed by David
Hume fails to account for its workings. Kant discovered that the
imagination is capable of forming mental pictures (*Einbilden* or
picturing internally, having something "in the mind's eye," as we
say) and of pretending, as well as creating worlds other than the
pedestrian work-a-day world we generally inhabit. This is essen-
tial since Hume had thought that the imagnation is merely the

capacity for filling in gaps between momentary sensations (called "perceptions"), therefore the capacity that enables us to perceive enduring entities—like tables and chairs—even when we have caught but momentary glimpses of one of their aspects, or the capacity to re-identify persons after an absence of many years or, say, the fire in the fireplace when we return to it after raiding the refrigerator or the obligatory jog. When Hume remarked in "Of the Standard of Taste,"[10] that, to do justice to a work of art, a critic must have a "delicate imagination," he meant that the critic must, in effect, possess an accurately calibrated sensory organ, an instrument competent to discern in an artwork details that others would tend to overlook—fail to see or find there—not that they must have the sort of imagination that poets like Wallace Stevens hope to kindle; imaginations responsive to metaphors, readers of poetry who need no intermediary to understand that:

> The first idea was not our own. Adam
> In Eden was the father of Descartes
> And Eve made air the mirror of herself . . . [11]

This is why, when contrasting Kant's doctrine with that of Hume, some philosophers dub the Humean theory of the imagination "the rowboat theory," presumably because rowboats, like Hume's "imagination," persevere in their line of motion in the interim between the oarsmen's strokes. Or else one might say that Hume regarded the imagination as though it were part of our sensory apparatus, whereas Kant viewed it as a capacity in its own right, not on all fours with hearing, seeing, and the others, not merely programmed to be predictably triggered by externally variable stimuli. Speaking historically, Kant's discovery makes his doctrine about the functioning of the human imagination genuinely innovative. This is the position toward which he points in (1).

A brief sketch of the background against which Kant set his aesthetic views should highlight other features pertinent to (1). The dominant "rationalist" theory Kant inherited was an offspring of Plato's, according to which "genius" was not an innate capacity that flourishes provided it is protected from shriveling or warping. It was not a native talent at all, but pictured as cartoonists with their lightbulbs picture it: a momentary flash of inspiration consequent on the unexpected and unexpectable visitation of a

divine agent. The dominant "empiricist" theory Kant inherited was one in which grand ideas of human creative prowess were deflated, and according to which the imagination merely reproduces or recombines ideas acquired earlier, or maintains the continuities we mentioned above. (Kant sometimes attributes this thesis to John Locke or George Berkeley; we have chosen a version attributable to Hume.) As against this, Kant instates his thesis that the imagination can be genuinely productive as well as reproductive.

Kant's way of contrasting the achievements of "great men of science"[12] and the masterpieces of "artistic genius" implicit in (3) and (4)—that geniuses do not know how they arrive at their ideas and that great artworks prescribe rules to the fine arts—can be regarded as a critique of the Platonic notion that scientists see the unchanging, universal Forms of things more accurately than persons without training in the sciences, whereas artists are notoriously unreliable guides. Like Kant's scientific hero, Isaac Newton, Plato's heroes, Pythagoras and Euclid, were capable not only of imparting their knowledge to others but learning from one another. The principal difference derives from Kant's picturing the process of scientific research as characterized by what we have come to know as the hypothetico-deductive method, whereas Plato pictured it as devoid of the formulation of hypotheses about the behavior of material, i.e., spatiotemporal entities. Plato failed to notice that an empirical scientist needs to formulate his question, or hypothesis, prior to "worrying nature," as Francis Bacon put it. One can account for this: Plato's model of science was geometry—Euclidian geometry—a "science" whose advance is independent of experimentation; Kant's model was physics—Newtonian physics—which relies on observable laboratory findings. Moreover, Kant's paragon scientist is an experimentalist who knows that his word is not the last or definitive word about his subject of inquiry. This conception of science is a consequence of the phenomenon/noumenon distinction so basic to Kantian "Critical Philosophy." The conception of the great man of science as one who stands on the shoulders of his predecessors, building on what his predecessors have done, is fairly straightforward—unlike the conception of the artistic genius's relation to his forebears—as we will show.

In keeping with his science/art distinction, Kant distinguishes

two types of success in *K.U.* The first occurs when "the scientist" arrives at a more penetrating comprehension of how and why things happen in the physical world and shows that his theory is both more comprehensive and more elegant than its predecessors. Kant's view of artistic success and failure brings out similarities and differences. The similarities are a function of the belief adumbrated in both (2) and (4): that art, like science, heeds its own past; artistic innovators "measure" their work against the great monuments of tradition; that young geniuses are inspired by confronting the history of art.

If we succeed in showing that Kant's conception of "artistic genius" helps explain the status of Jackson Pollock's art, we will succeed in silencing the skeptic, who supposes that an esoteric, philosophical theory dating from 1790 must be hopelessly outmoded and irrelevant to questions about entirely abstract paintings of this century. Instead of proceeding to this project directly, let us continue our elucidation of Kant's argument.

Consider (1) next, particularly the talent/aptitude distinction Kant introduces there. He returns to this distinction in #43 and again in #49 in the course of contrasting art as "skill" *(Geschicklichkeit)* from practical "know-how" rather than theoretic "knowing-that" *(Koennen von Wissen)*. A footnote provides one of Kant's rare illustrative examples. Consider the art of juggling with that of tightrope dancing, he says in effect. Would not a "common man" say that juggling is not an art, but a mere skill, i.e., a feat anyone can bring off, provided he *wants* to? Would not this same "common man" assent that tightrope dancing is an art?[13] The implication is that "art" is unlike "skill" in that skills can be acquired by learning how to become a proficient practitioner, and that such proficiency is available to anyone willing to imitate, or go through the motions—here, the motions of juggling—often enough to become as adept at the routine as the person being imitated *(Nachahmung)*. The point of (1) is similar, although this time cleverness as "skill" is contrasted with art as "craftsmanship" or technical mastery. A skill, Kant thinks, can be acquired by single-minded commitment to the practice or task that seems to involve internalizing some rules of procedure: practicing by doing, practicing until doing becomes one's second nature. Mastering an art (as distinct from a craft)[14] is not like that, although it, too, involves acquiring requisite artisanal skills and perfecting

them until they become as if inborn. What distinguishes fine art from art as craft is that in pursuit of the former, individualized talents or gifts eventually surface as visions or ideas in the would-be-master's mind. Technical virtuosos may be skilled craftsmen, but not all skilled craftsmen are creators of wonderful art. (Highly tuned violin virtuosos may, as they say, go through an entire career without ever acknowledging a musical idea as their own.[15] The same holds for expert calligraphers, master stone masons, superior draftsmen, and many others.) Think of an artistic genius—Raphael, for example—who was both a craftsman and an artist. Think first of Raphael following in Perugino's footsteps, then struggling to realize that breadth and "poetry" of his own unique vision which enabled him to create paintings that were truly his. These are the masterpieces that have made him a continuously loved, canonical master for the five hundred years separating twentieth-century America from Renaissance Italy. One wants to say that Raphael's story shows that he heeded Da Vinci's admonition that a good pupil should excel his master: it makes good sense to characterize Raphael's relationship to Perugino in precisely these terms.

If the visions and ideas that set Raphael apart from and above his master—as well as revitalizing Perugino's painting from within—then the "Perugino-Raphael" story reveals a salient feature of the historical evolution of art, and points toward Kant's thesis regarding the "originality of genius." The same story explains and supports Kant's fifth thesis—that artistic genius manifests itself in the capacity for *"presenting aesthetic ideas"*—by providing a telling illustrative example. One might put this the other way round, since theory and empirical data ideally interact. That is, one might comment that Raphael's forty variations on the mother-and-child theme—starting with the first, made when Raphael was in his early twenties and culminating in the *Madonna della Sedia* completed just prior to Raphael being summoned to Rome in 1508 by Pope Julius II—reveal precisely the type of development or maturation that makes good sense if one interprets it using Kant's hypothesis. In those days the great challenge was to find a way to paint the mother of God and her child as both human and divine. To be good as art it would also have to be good as religion. Raphael achieved exactly this in paintings that identify themselves as uniquely his. One sees it better when

noticing that, traditionally, the Madonna had been depicted as reading her future in the "Book of Prophets," whereas Raphael's Madonnas eventually dispense with this bit of iconography as they also dispense with the goldfinch that had remained as symbol of the infant's message and martyrdom in the predecessor paintings. In Raphael's later paintings one can read their destiny in their eyes.[16] In short, the gradual transformation of Raphael's vision along with the gradual emergence of his unique hand is a clear instance of an artist who discovers his "aesthetic idea."

Another instance of such maturation of vision is Raphael's introduction of St. Elizabeth and her child, John the Baptist, into the traditional or conventional representation of the Madonna and the infant Jesus. Although we may not be able to articulate how or why this subtle iconographic change moves us, it does show that "aesthetic ideas" are not rationed, while suggesting that they may be precious by virtue of being rare.

Kant's reason for using the term *exemplary* in characterizing artistic masterpieces, is to call attention to their role in the self-education of aspiring artists. They are works worthy of imitation, and capable of inspiring a would-be artist to go in search of his unique wings. This is what occurred when Raphael studied Leonardo's drawings, Filippo Brunelleschi's *Doors of Paradise* to the baptistry in Florence, and Michelangelo's *David*, for example. Raphael may have made sketches of each and every one in hopes of learning what could be incorporated into his own style. If he did this, these Florentine artworks were, for him, both objects for imitation (copying) and emulation. In other words, they were "exemplary." Kant taught Heinrich Woelfflin that all paintings owe more to other paintings than to direct observation[17]—a lesson also imparted by such twentieth-century teachers as T. S. Eliot and Sir Kenneth Clark. The latter's notion of the "density" of masterpieces summarizes this. He demands that a masterpiece be "not one man thick, but many men thick."[18] Eliot expresses it by saying that "no poet, no artist of any art, has his complete meaning alone."[19]

The importance of (3)—that there is no recipe for creating an idea of genius—is as a reminder that demonstrations are part-and-parcel of an introductory course in physics and that the scientific community will not accept the written report of a discovery unless the experiment leading to it can be replicated. In

the world of art there are neither dissecting tables nor replica-
tions—barring forgeries. Even Leonardo's detailed "Notebooks"
tell more about him than about making art and are themselves
more like artworks than like laboratory reports or physics text-
books.

When an artistic genius emulates the masterpieces crafted by
his or her predecessors, the history of the art form in which
he or she works is changed. This is what happened when Ra-
phael outgrew Perugino, and when Luca Signorelli outgrew Ra-
phael as a painter. The sculpture with which Giovanni Lorenzo
Bernini filled in some panels Raphael had not finished are un-
mistakably the creations of a sculptor who had learned from
Raphael, as sculptor, but had gone his own way—as a sculptor
working a century later is virtually bound to do. The direction of
influence may be overdetermined, as we saw when we noted
that Raphael learned not only from Perugino, but also from Leo-
nardo and Michelangelo, Brunelleschi and Donato d'Agnolo
Bramante. It is nevertheless an evolutionary process that, on oc-
casion, assumes all the characteristics of a revolution: the High
Renaissance, for example.

II. Jackson Pollock

Having set out some of the queries Kant raised and answered, let
us consider three of Pollock's paintings that are candidates for
masterpiece-ranking. Our initial response to them is clearly not a
response to their subjects. Nor do we feel respect, even amaze-
ment, that the painter has been able to dominate a great mass of
material, as we do when contemplating Tintoretto's *Crucifixion*,
Rembrandt's *Night Watch* or Gericault's *Raft of the Medusa*, for
example. Nor, finally, can we say that they show a devotion to
truth that has never been equalled, as we can and do, say, of
Velazquez's *Las Meninas*. What sort of response is appropriate
and telling when a picture is as nonrepresentational or as highly
abstract as the pictures the mature Pollock created? It will not do
to say that this is a response to their being superb examples of
technical skill, or consummate imitations of reality.[20] What was
the great challenge in the middle decades of our century when
the pictorial language of the day had, for complex reasons, be-

come incomprehensible to the majority of men and women? It was not the challenge Raphael met, nor Rembrandt nor Velazquez.

The three paintings on which we have chosen to concentrate are mature paintings of the 1940s and early 1950s. The first is *Male and Female* (c. 1942), a painting of extraordinary ambiguity-within-order; the second is *Number 1A* (1948) in which Pollock's handprints are visible at the top and sides; the third, *Lavender Mist: Number 1* (1950), is an "optical" painting in which color works as a powerful emotional agent.[21]

Does *Male and Female* meet Clark's demand that a masterpiece be not "one man thick, but many men thick?" No one can analyze its subject. But consider what Pollock wrote in applying for a Guggenheim Fellowship in 1946:

> I intend to paint large large movable pictures which will function between the easel and the mural. . . . I believe the easel picture to be a dying form, and the tendency of modern feeling is towards the wall picture or mural. . . . The pictures I contemplate painting would constitute a halfway state, and an attempt to point out the direction of the future. . . .[22]

Elizabeth Frank adds that Pollock made great art out of this "halfway state,"

> preserving the tension between the easel picture with its capacity to draw the viewer into a fictive world, and the mural, or wall picture, with its power to inhabit the viewer's own space.[23]

Although this does not expressly tell us why Pollock wanted to preserve the tension between easel picture and wall picture, or what Pollock took to be the substance of "modern feeling," it seems helpful inasmuch as it alerts us to Pollock's "purism," i.e., to his passion for painting for painting's sake, which was the formalist Modernist imperative. But it also invites one to ponder why *Male and Female* simultaneously possesses figure and yet is abstract. According to Frank, Lee Krasner pointed out that many of the abstract paintings "began with more or less recognizable imagery—heads, parts of the body, fantastic creatures," and that, in reply to a question raised by Krasner, Pollock replied, "I choose to veil the imagery."[24] All of this suggests that Pollock deliberately

evokes Miro, Picasso, and Mexican mural painting, which, in turn, suggests that the figures in this 1942 painting are hieroglyphs: a symbolic marriage, perhaps, with its allusions to an easy sensuality—contrasting with the powerful political messages of José Clemente Orozco's murals.

Perhaps an account along these lines would reveal that *Male and Female* satisfies Clark's requirement of "thickness" or density. Then Frank's story would also be material. She observes that the ambiguous sexuality of the figures enhances the painting's power, as does its reference to other painting styles or schools:

> Surrealism and Cubism mesh as the two totemic figures function simultaneously as images and as vertical planes in a sequence of such planes establishing the picture's rectilinear flatness. The images themselves could not be more tantalizing. . . . The title does not clear up [the ambiguity].[25]

Her point seems to be that Pollock's familiarity with Surrealistic imagery and Cubist composition makes it easier for the viewer to get a handle on this painting, even while recognizing that it represents Pollock's attempt to resolve problems with which Surrealism and Cubism had grappled; an uneasy resolution at best. Cubists confronted the challenge of revealing an object's inner structure; the Surrealists, that of letting an object be a revelation of the viewer's unconscious desires as triggered by the object chosen. Whether such diverse problems can be resolved simultaneously seems to us an open question. Can totemic figures or images whose sexuality remains elusive serve both to reveal structure and satisfy repressed needs? Do they constitute analogues for the famous madeleines from Marcel Proust's *Remembrance of Things Past*, the taste of which suddenly unlocked the writer's memory, releasing a flood of associations that structure the pages of his masterpiece.[26] There is no unambiguous trigger. The figure on the left appears to be female, having breasts and a possible womb; that on the right, less certainly appears to be male: there is no clear sexual identity for either, since it is possible to discern male and female attributes in each. Put in somewhat different terms, our point is that, although *Male and Female* is intriguing, possibly endlessly intriguing, it won't quite stack up against the masterpieces of the tradition—partly because no rec-

cognizable figure, not even an androgynous one, can be found. There is no place to start or stop. What one sees, instead, are passages yielding to other passages in an enriched virtuoso vocabulary of spatters, drips, swirls, scrumbles, filled-in shapes, arabesques, and hieroglyphs of a painterly calligraphy that "for all its energy, never crowds or squeezes the picture."[27] Mysterious, perhaps; but we hunger for more.

Notice that in this painting, with its allusions to Cubism and Surrealism, Pollock reveals his familiarity with what was then called "The School of Paris" tradition, which we tend to denominate "French" or "International Modernism." To the best of our knowledge, serious studies of Jackson Pollock invariably document his long-standing familiarity with artworks of this provenance, pointing out that his eldest brother, Charles, occasionally sent copies of *The Dial*, the New York magazine of avant-garde art and literature, to young Jackson in California, starting in 1926.

These studies also point out that, given the "Presbyterian" seriousness of concern with high standards of personal worth and inner direction in the Pollock family, it is hardly surprising that when Jackson was fourteen he was not too young to start thinking about his own future. Despite the rebelliousness that caused his expulsion from school, and the self-doubts he conveyed in letters to his brothers, he was curious about the technical aspects of art and eager to receive criticism, advice, and book lists from them. When Frank and Charles Pollock returned to New York in September, 1930, the provincial but unparochial Jackson went with them and registered at the Art Students League. He was evidently determined to find out whether "i have it in me . . . to make an artist of some kind" (as he had written in an earlier letter), despite his reservations about his drawing and himself.[28]

Jackson Pollock's teacher was Thomas Hart Benton, whom Pollock considered the most important painter in America:

> My work with Benton was important as something against which to react very strongly later on; in this it was better to have worked with him than with a less resistant personality who would have provided a much less strong opposition.[29]

Pollock's earliest known paintings date from his studies with Benton at the Art Students League. Elizabeth Frank comments that

"from the very beginning, they show four qualities that were to remain permanent in his work: assured totality of conception, dynamic rhythm, unfailingly articulate touch, and emphatic contrasts of light and dark."[30] We have entered our reservation to the claim about the "totality of [his] conception." We do not, however, take exception to Frank's argument that Jackson Pollock's continued interest in Regionalist motifs shows the influence of Albert Pinkham Ryder, of whom Pollock later said that he is "the only American master who interests me."[31]

If one wishes to emphasize the Americanness of Pollock's genius, one could refer to many paintings from this phase of his career: *Going West* and *Landscape with White Horse*, for instance. One could point out that the bull's head in *Bull, Bird* (c. 1938-41) may well be a remnant from Pollock's earliest Western motifs. Rosalind Krauss has discerned yet another: the resemblance to American Indian motifs in what have come to be known as Pollock's "psychoanalytic" drawings of the late 1930s and early 1940s.[32] But by then the inward or isolated Pollock-moth had already been transformed into the Pollock-as-vacuum-cleaner-chrysalis, vacuuming up whatever he saw: Jungian symbols, American Indian motifs, Picasso's Minotaur images, Graham's "automatic ecriture," and the idea of exploiting "the immediate, unadorned record of an authentic intellecto-emotional REACTION of the artist set in space. . . .[33] In sum, the story of American-born and American-bred Jackson Pollock does not much look like an *American* success story—if one means by that an isolationist story—of a gifted individual whose imagination was bounded by people who pledge allegiance to the American flag or by territories that fly it.[34]

Our question regarding the status of Jackson Pollock and his work persists. Did he succeed in creating genuine masterpieces? Does he merit the accolade "artistic genius"? Although we have indicated some doubts, we should firm up and elaborate our position. We propose to do this by discussing the second of the three masterpiece-candidates selected above, *Number 1A*, and then the third, *Lavender Mist: Number 1*. Owing to constraints of time and to those imposed by the very nature of an essay, a very brief discussion will have to serve our purpose, for we do judge that these are successes.

The painting titled *Number 1A* is dated 1948, but as early as 1946 Clement Greenberg sang Pollock's praises. He considered the

artist's 1946 show to be the best since Pollock's first, noting the presence of high, sharp color, but adding:

> Pollock remains essentially a draftsman in black and white who must rely on these colors to maintain the consistency and power of surface of his pictures. As is the case with almost all post-cubist painting of any originality, it is the tension inherent in the surface that produces the strength of his art.[35]

Greenberg also observed that Pollock was moving in a direction beyond the framed easel picture and toward the mural; as we have seen, Pollock himself said as much.

By 1948, when *Number 1A* was completed, Pollock was already expert at dipping and pouring fluid enamel, aluminum, and oil paint from sticks and hardened brushes over pieces of sized unprimed canvas tacked to the floor of his Springs studio. Pollock had known about the practice of dripping and pouring paint for some time, but waited until he had a problem that pouring alone could serve before making it an integral part of his painting. That problem, Elizabeth Frank tells us, was centered in the inhibiting and retarding effects of brushwork. The stops and starts of loading, unloading, and reloading the brush raised a specter of psychic censorship inimical to Pollock's idea of automatist directness and authenticity. Pollock evidently developed his "willful actively directed drawing-with-paint"[36] to circumvent the constraints of drawing as contour and to encourage a more direct contact with the unconscious.

We noted earlier that Pollock's handprints are visible at the top and sides of *Number 1A* and should now add that these appear to be intentional, functioning as signs of the artist's literal presence in his painting, as well as signs of the painting's literal presence as a made and felt work of art that begins and ends in the use of materials. Frank cites Pollock's own description of his painting practice.

> When I am in my painting, I'm not aware of what I am doing. It is only after a sort of "get acquainted" period that I see what I have been about. I have no fears about making changes, destroying the image, etc. . . . It is only when I lose contact . . . that the result is a mess. Otherwise there is pure harmony, an easy give and take, and the painting comes out well.[37]

In *Number 1A* we see that Pollock limits the field of his painting, evidently conscious of the framing edge as the point of demarcation between the picture and "real" space. He achieved this by keeping the selvages at the top and bottom edges, by letting rhythmic lines touch the edge and rebound into the painting. Within the tracery of the poured paint Pollock achieved a style that Michael Fried characterizes this way:

> [His line] is entirely transparent both to the non-illusionistic space it inhabits but does not structure, and to the pulses of something like pure, disembodied energy that seem to move without resistance through them. Pollock's line bounds and delimits nothing— except, in a sense, eyesight. . . . In a painting such as "Number One" there is only a pictorial field so homogeneous, overall and devoid of recognizable objects and of abstract shapes that I want to call it optical.[38]

Fried's point is that the use to which Pollock puts the different elements in his painting—most importantly line, but also color— marks a historic moment: the first time in Western painting when these function as wholly autonomous pictorial elements.

Frank adds that eyesight cannot be as easily divorced from the sense of touch as Fried believes. "Tactility," she observes, "is not limited to the implications of three-dimensionality" and, she continues:

> Pollock's encrusted, puddled, labyrinthine and weblike surfaces are physically, erotically, present, and entice the viewer into a relation in which his body, and not just his eyesight, directly confronts the abstract field.[39]

We think Frank's interpretation somewhat fanciful, and should prefer to replace her references to "eros" and "body" with references to the powers of the viewer's active imagination when attending to Pollock's "autonomous" line and sees its sharp physical quality as it cuts with silken thinness through the pulverized skeins and webbings. Nevertheless Frank helped us, as did Greenberg and Fried, by supporting our claim that *Number 1A* is a masterpiece.

We should like to conclude the discussion of *Number 1A* with poet Frank O'Hara's response to the polymorphous potency of Pollock's line. He wrote:

> There has never been enough said about Pollock's draftsmanship, that amazing ability to quicken a line by thinning it, to slow it by flooding, to elaborate that simplest of elements, the line—to change, to reinvigorate, to extend, to build up an embarrassment of riches in the mass of drawing alone.[40]

A few words about *Lavender Mist: Number 1* (1950) should suffice to establish the thesis that two of the three Pollock masterpiece-candidates we have selected are so wonderful that one can look at either of them for an hour, as we have done, turning away and turning back, and discover something new at each turn. We chose this 1950 painting because its pinkish haze gives an unearthly softness and because it stands out in contrast with Pollock's earlier work that only rarely emphasizes color for its own sake. Although hues occur throughout his work, they are usually used in minute quantities, tending to arrest the eye and give local intensity to variations in the overall configuration, accenting the intricate layering of flung or spilled paint; they do not serve as emotional agents as the pinkish haze does here. We agree with Frank that at least some of Pollock's 1947-50 paintings "remain astonishing feats of pictorial invention."[41]

Interpretations of Pollock's mature paintings abound; for our purposes, it chiefly matters that Pollock's mural-sized paintings are clearly not part of the history of painting, which took it for granted that painting is (and was) about telling stories without words. As long as paintings were narratives of biblical or historical events one might argue that Raphael was revered as perfection itself. This, it may reasonably be said, held true for three-and-a-half centuries—at any rate, from Raphael's twenty-fifth year (in 1508) until Jean Auguste Dominique Ingres, whom many regard as the last of Raphael's devotees—although echoes of Raphael's *Massacre of the Innocents* have been found even in Picasso's *Guernica,* which is, in its way, also a depiction of the massacre of innocents.

Picasso knew his Raphael and used Raphael as Raphael had been used by countless other Western masters, to provide a sort of "visual memory bank." If it makes sense to construct a visual genealogy from Picasso's Spain in the early 1930s to Raphael's Italy in the sixteenth century, Pollock is odd man out, the artistic counterpart of a sport in genetics, a result of an unpredicted mutation.

There may be irony in the fact that Pollock arrived in New York City and started studying at the Art Students League at about the time Picasso cried out in horror at the politics and bloodshed brought on by the Spanish Civil War. Was it irony or a vital clue to our question about Pollock's status and/or stature as a painter?

As noted, Pollock was not unschooled in the discipline of life-drawing, painting, and composition as these were taught in art academies in the United States and on the Continent, and there is ample evidence that Pollock was well-versed in the so-called "School of Paris."[42] He did not find his wings, however, until he started exploring the new freedom an artist gains when he chooses to use "spray guns and air brushes along with the latest paints and lacquers":[43] a new freedom that still seems to many to have revolutionized the art of painting.

Can we say that the great utterly abstract paintings of Pollock are masterpieces; that Pollock was a painter of masterpieces? Perhaps, though we equivocate: there is that within us which yearns for artists and artworks that are deeply involved in the understanding of our fellow men. We are not yet convinced that the mysteries Pollock's work create serve to supplant our need for myths to live by.

NOTES

1. Immanuel Kant, *Kant's Critique of Aesthetic Judgement* (henceforth *K.U.*), translated by James Creed Meredith (Oxford: Clarendon, 1911). Our references here are to Sections 46-50, pp. 168-183; the corresponding lines in the standard Prussian Academy edition are 1.307-320. Although we normally rely on Meredith's translation of the German text, we shall, on occasion, use our own translations or emendations. We do this in the interest of making Kant's tortuous prose somewhat more intelligible for contemporary readers.

2. Throughout his philosophical works Kant used the terminology of the "faculty psychology" of his time. Since we believe that in doing this, Kant argued from function to faculty and that his use of "faculty" corresponds to the contemporary psychological term "capacity," we adopt the current idiom.

3. If we were to conduct a more sophisticated philosophical inquiry, we should have to pause and explain why these "requisites" or "factors" are not strictly necessary conditions, nor severally or taken together, sufficient conditions, and launch into a discussion of Kant's notion of "indeterminate concepts." For purposes of this essay, such an elaboration seems needlessly abstruse.

4. Kenneth Clark, *What is a Masterpiece?* (London: Thames and Hudson, 1979), p. 12. Clark's point is not the same point T. S. Eliot emphasizes in "Tradition and the Individual Talent," but there are salient similarities to which we shall allude in the course of introducing what Clark terms the "density" of a masterpiece. Eliot's essay is included in his *Selected Essays* (New York: Harcourt Brace, 1932), pp. 3-11.

5. Our readers may wonder why we move from back to front in discussing Kant. The explanation is that, as serious students of Kant's philosophy, we learned long ago that Kant's order of presentation is not always the order of demonstration. Put simply, it is often easier to understand what Kant means to argue when one reads him back to front.

6. George Sand, quoted by Francis V. O'Connor in *Jackson Pollock* (New York: The Museum of Modern Art, 1967), p. 30.

7. *K.U.* #46., pp. 168-169. The underlinings are in the text; some bits and pieces are our own translations, not Meredith's.

8. Ibid., #48, p. 181 (1.318).

9. Our term *interplay* may sound odd. We use it to capture Kant's notion of "the free play of the imagination and understanding," as presented in #10, pp. 61-62 (1.220-221). It is the English counterpart of Kant's "Harmonie der Erkenntnisvermoegen . . . die hierbei in einem freien Spiele sind."

10. David Hume, "Of the Standard of Taste," in *Hume's Ethical Writings*, edited by Alasdair MacIntyre (London: Collier, 1965), pp. 275-295.

11. "Notes Toward a Supreme Fiction," in *The Collected Poems of Wallace Stevens* (New York: A. Knopf, 1957), pp. 380-404.

12. *K.U.* #49, p. 180 (317-318).

13. Ibid., #43, p. 163 (304).

14. Of the many philosophical discussions of the differences between art and craft, R. G. Collingwood's seems best. See "Art and Craft" from his *The Principles of Art* (Oxford: Clarendon, 1938), pp. 15-41.

15. It is said by Christopher Small, for example. See "Music: A Resource for Survival," *Musical America* (November 1985): 6-10.

16. Mother and child also, and for the first time, become a convincing family in Raphael's rendering of them.

It is not entirely clear whether Clark ranks the *Madonna della Sedia* among Raphael's "highest masterpieces." This may be owing to the fact that Clark reserves the category of "highest masterpiece" to paintings that illustrate great tragic themes. It is, however, clear that Clark does not believe that tragedies need necessarily involve Christian religious themes. See Clark, pp. 20-39.

17. Heinrich Woelfflin's lesson is summarized by E. H. Gombrich in *Art and Illusion* (London: Phaidon, 1960), p. 317. It is our hypothesis that Woelffflin learned it from Kant.

18. Clark, p. 11.

19. T. S. Eliot, p. 4.

20. Someone might argue that a random, chaotic, unpredictable world guided by chance—an abstraction—may provide the model for an artist like Jackson Pollock, whose work may be considered to that extent mimetic. This interpretation strikes us as too farfetched. But see Gary Hagberg, "Aristotle's Mimesis and Abstract Art," *Philosophy* 50 (1981): 356-371.

Rosenberg has argued that, "at a certain moment the canvas began to appear to one American painter after another as an arena in which to act. . . . What was to go on the canvas was not a picture but an event." See Harold Rosenberg, "The American Action Painters," *ARTnews* 51 (December 1952). We dismiss his argument, but do not think it necessary to mount a rebuttal here.

21. In making these choices we were greatly helped by Elizabeth Frank's *Jackson Pollock* (New York: Abbeville Press, 1983). We are also indebted to O'Connor, 1967. The roles of Clement Greenberg and Michael Fried will become evident below.

22. Francis V. O'Connor, "The Life of Jackson Pollock, 1912-1956," in *Jackson Pollock: A Catalogue Raisonne of Paintings, Drawings and Other Works,* edited by Francis O'Connor and Eugene Victor Thaw (New Haven, Conn.: Yale University Press, 1978), p. 238.

23. Frank, p. 63.

24. Ibid., p. 43.

25. Ibid., p. 41.

26. The exhibition *L'Amour Fou* at the Corcoran Gallery of Art in October, 1985, put us in mind of these Surrealist concerns.

27. Frank, p. 41.

28. See Frank, and V. O'Connor, 1967.

29. Cited by Frank, p. 18.

30. Ibid., p. 18.

31. Ibid., p. 20.

32. Cited by Frank, p. 34.

33. Graham, born with the name Ivan Dambrowsky, cited by Frank, p. 25.

34. For a discussion of this definition of American art, see the essay in this volume by M. Quillard.

35. Clement Greenberg, "Jean Dubuffet, Jackson Pollock," *The Nation* 164 (February 1, 1947): 137.

36. William Rubin, "Jackson Pollock and the Modern Tradition," part 1 *Artforum* (February 1967): 18.

37. Frank, p. 68.

38. Michael Fried, *Three American Painters: Kenneth Noland, Jules Olitski, Frank Stella*, exhibition catalog (Cambridge, Mass.: Fogg Art Museum, 1965), p. 14. Fried's *Number One* is the painting we call *Number 1A*.

39. Frank, p. 71.

40. O'Hara, cited by Frank, p. 71.

41. Frank, p. 72.

42. O'Connor, 1967, p. 11.

43. Ibid., p. 21.

Eight

The Crystal Palace, van der Rohe Style

Inga Freivalds and Ingrid Stadler

The idealization of glass in architecture which we associate with the BAUHAUS had multiple roots. One points to the visionary writings of Paul Scheerbart, whose poems and stories are generally ranged under the rubric "German Expressionism." Scheerbart's uniquely fantastical and phantasmagorical prose attests to his reverence for glass.

> The surface of the earth would change totally if brick buildings were replaced everywhere by glass architecture. It would be as if the Earth clothed itself in jewelry of brilliance and enamel. The splendor is absolutely unimaginable . . . and then we should have on earth more exquisite things than the the gardens of the Arabian Nights.[1]

The architect Bruno Taut[2] was one of Scheerbart's close friends and ardent admirers. He hailed Scheerbart as "the only poet in architecture." Scheerbart, for his part, is responsible for the inscription on Taut's most important architectural achievement, the Pavilion at the Werkbund Exhibition of 1914 in Cologne, Germany. This pavilion, we are told, was built to "demonstrate the use of glass in all its varied aesthetic charm."[3] Its structure was of concrete lamellar. Almost everything in it was made of glass: the walls, ceilings, floors, tiles, and a cascade that was lit up from beneath. The nighttime illumination of the large interior kaleidoscope was to reveal how glass can raise "the intensity in our lives."[4]

Bruno Taut had other, more fantastical projections. There was, for example, his portfolio for *Alpine Architecture*, of 1919, containing thirty drawings intended for use as blueprints of glass structures and entire communities atop the Swiss Alps. However compelling or appealing Taut's utopian visions may have seemed to a generation in the process of recovering from the horrors of World War I, the possibility of their execution was, at best, remote. Glass houses, and entire communities of residences produced of glass houses might work in a world where none throw stones or let bombs fall, but ours was not then, and is not now, approximating these ideals.

An excerpt from Paul Scheerbart's essay "Glasarchitektur," which appeared in *Der Sturm* in 1914, helps explain how the romantic visions of this German Expressionist fused with Mies's Minimalist standard of "almost nothing" (*beinahe nichts*). Scheerbart observed that

> [we] live for the most part within enclosed spaces. These form the environment from which our culture grows. Our culture is, in a sense, a product of our architecture. If we wish to raise our culture to a higher level, we are forced, for better or for worse, to transform our architecture. And this will be possible . . . only through the introduction of glass architecture that lets the sunlight and the light of the moon and stars into our rooms. . . . The new environment . . . must bring with it a new culture.[5]

In this passage Scheerbart conveys his luminous images while, at the same time, hinting at the functionalist[6] ideals to come. But let us, instead of proceeding to Mies directly, sketch yet another scenario of the background of the aesthetic ideals of the Neues Bauen movement, of which Ludwig Mies van der Rohe has long been recognized as one of the founding masters—along with Marcel Breuer, Le Corbusier, and Walter Gropius.[7]

Kenneth Frampton, in his preface to *Mies van der Rohe*,[8] reminds the reader that other romantic visions blended with Mies's own classicizing, rationalizing, and standardizing predilections:[9] the ineffable, misty light of Caspar David Friedrich's landscapes and "the ethereal silence of Malevich's Non-Objective world."[10] Frampton maintains that, despite Mies's denial that the Russian avant-garde had made any impact on his thought and

work, "there remains an uncanny affinity" between his work and the sensibility of Russian Suprematism; in particular, between Mies's own projections and the visionary projects of the Neo-Suprematist architect Ivan Leonidov, who was acclaimed for his success in capturing the silence and light of the natural world in his created one. Frampton buttresses his contention by calling attention to a number of exhibitions staged by Mies in the late 1920s, which suggest that we are following the right tack.[11] The generally unacknowledged quasi-mystical aspect of Mies's career thickens the web of Expressionist and/or Romanticist influences in the architecture of the man known by the vulgar as the cold aesthetician of corporate architecture. But even Frampton finds it "curious" that Mies, speaking of his early brick houses, remarked that he would have liked to use more glass in making them.[12] We do not regard this as "curious" at all, but as strong evidence for our thesis that there is as much of the mystic as there is of the "rational" in Mies's modern masterpieces.[13]

David Spaeth, in the body of the text for which Frampton had produced his Preface, applauds the creativity and originality that marked Mies's work during the five years after the armistice that concluded the First World War. He cites the two Glass Sky-scrapers (1919–1921) and the Concrete Office Building (1922)—calling them "seminal projects"[14]—as well as the Brick Country House (1923) and the Concrete Country House (1924). But, unlike ourselves, who would look to these to show the influence of romantic visions on Mies's work during this five-year period, Spaeth looks for and finds, the clarity with which these designs demonstrate the spatial and structural potentials of the materials generally associated with modern architecture: glass, steel, and reinforced concrete. We assent to this description. We differ, however, in drawing a markedly different conclusion. Ours is not necessarily an attempt to contradict Spaeth's "standard" inter-pretation; we do, nevertheless, undermine it in so far as we implicitly charge it with being one-sided or partial. To demon-strate the principal difference between these two positions, it will be helpful to have Spaeth's conclusion at our fingertips.

> The idea which unifies these projects derives from the thesis that is fundamental to understanding Mies's architecture: that tech-nology is the most significant force animating architecture and

society in the twentieth century. . . . It is, to quote Mies's famous phrase, "the will of the epoch."[15]

Spaeth reverts to this theme over and over again. For example, he adds that "All of Mies's work was predicated on technology, its possibilities and its expression."[16] We do not dispute the claim that Mies took pleasure in exploring the horizons opened up by technological advances. We do dispute the implicit claim that understanding Mies's exploitation of technology is the key to understanding his genius.[17] Put into somewhat different terms, our contention is that Spaeth errs by implying that a position like ours must be based merely on superficial similarities between Mies's work and that of the German Expressionists. We do not agree that, although there are salient similarities between the aesthetics of Mies's work and the aesthetics of German Expressionism, there are none with respect to attitudes or underlying philosophies.[18]

Another outspoken historian and critic of twentieth-century architecture sides with Spaeth in believing that Mies's Modernism suppressed its classicism behind a technological imperative.[19] For reasons of brevity, we sidestep others who subscribe to variants of this architecture and technology theme in their discussions of Mies.

For our purposes it will be useful to focus attention on one set of Mies's early drawings, the ones representing the Office Building, Friedrichstrasse, Berlin (1919). We think they are as familiar as the plan and model of the Glass Skyscraper of this period and believe that they may be more pertinent to our argument.

The charcoal sketches represent a structure of three wings composed around the circular core, which was to contain the stairways, elevators, and public facilities. For our purposes, the most significant feature of this set of drawings depicting the plan of the proposed structure is what they reveal about Mies's conception of the exterior of an office building: it was to be a surface that would allow sunlight to illuminate all the interior spaces.[20] These sketches show Mies's preoccupation with glass, even though he did not, at this time, envision using glass for large surfaces of all his commissions (the Brick Country House, for example).

In the Office Building, he already demonstrated what would prove to be a continuing investigation into the transparent, translucent, and reflective qualities of glass. In the plans for the Friedrichstrasse building, one sees Mies exploiting the capacity of glass to reflect light when it is broken up into angular modules, and exploring the idea of utilizing these reflections for illumination while creating the effect of grounding the structure, making it look firm and solid. The sketches show a building whose glass walls rise to the top, and are then sharply cut off, unadorned by cornices. Contemplating these drawings, one discovers that the building's prismatic plan creates a romantic vision: the continuity of an uninterrupted ceiling plane revealing an impulse toward infinite spatial continuity, and the non-load-bearing exterior, with its glass panes set at oblique angles to one another, contribute to make it look like a crystal—or ice—palace.

Something of Mies's reverence for glass is echoed in Walter Gropius's characterization of the aims of the BAUHAUS, which he founded in 1919. Gropius characterized the new academy as a "crystal symbol of the new faith" and incorporated this phrase into the BAUHAUS manifesto. Robert Hughes quips that "Like virtue itself, [glass] was pure, unyielding, readier to break than bend."[21] We will see that Mies went a step further than Gropius in his post-World War II career, when he opted not only for the architectonic of the rolled steel section, but also for the technological breakthrough that made sheet glass abundant. More importantly, Mies evidently made these choices thinking that exploiting the physical properties of glass would enable him to give free rein to his consistent concern about perfecting the details of each artifact: the sort of respect for details that makes for very simple and beautifully crafted structures. His famous aphorism that God is in the details informed everything he made. Each of his works also exemplifies the emphasis Mies put on the qualities of the materials themselves and on how best to reveal their essence: in this case, the purity and clarity of sheet glass. His own words say it best:

Advancing technology provided the builder with new materials and more efficient methods which were often in glaring contrast to our traditional conception of architecture. I believed, nevertheless, that it must be possible to harmonize the old and the new in

our civilization. Each of my buildings was a statement of this idea
and a further step in my search for clarity.[22]

We know that in 1927 Mies was appointed director of the
second Werkbund exposition, the Weissenhofsiedlung, Stuttgart,
Germany, and that because Mies did not wish the exhibition to
appear "one-sided or doctrinaire," he invited "the leading repre-
sentatives of the Modern Movement to make their contributions
to the problem of the modern dwelling."[23] Nevertheless, history
tells that the critics and the general public saw only the similari-
ties: the flat roofs, the predominantly white, unadorned surfaces,
the simple interiors.[24]

Since we wish to describe the real differences that obtained
between Mies and his architectural colleagues, in particular, to
bring out the distinguishing features of his ambitions, it is helpful
to begin by contrasting Mies's modern Minimalist aesthetic with
the one featured by architect Adolf Loos in his 1908 polemical
essay "Ornament and Crime." Loos argued that "cultural evolution
is equivalent to the removal of ornament from articles in daily
use,"[25] but the stridency reflected in the title of his essay is pal-
pable throughout the argument, weakening it. We contend that
the spiritual basis of Mies's work is the polar opposite of Loos's.
Mies's stems from envisioning the process of building as poetic
gesture. He writes that:

[a]rchitecture is a language having the discipline of a grammar.
Language can be used for normal day-to-day purposes as prose.
And if you are very good you can be a poet.[26]

To be "a poet" rather than a prose writer in the language of
architecture summarizes Mies's persistent objective. Although
poets have, on occasion, thought that their poetry could or should
be engines for advancing "cultural evolution" (Berthold Brecht
for example), such poets were the exception, not the rule during
the years of the Weimar Republic (1919–1933). There is no evi-
dence of any interest in "advancing culture"—whatever that may
mean—in Mies's work. His architectural achievements have long
been hailed as the achievements of "an architect's architect,"
demonstrating, as they do, that his energies were directed toward

a "purist," not a "political," ideal. The same holds true of his approach to the functional, technical, and aesthetic problems posed by the design of modern furniture. The "classical" furniture pieces he produced during the mid-1920s evidence that Mies was not content to refine details and proportions of existing furniture, nor was he interested in contributing to the then lively debate of wood versus metal for furniture. He believed and showed, rather, that each material had its appropriate use and expression, that no one material was inherently better than any other. Among the furniture for which he is best known are the famed Barcelona chair of 1927 and the furnishings created in 1930 for the Tugendhat House in Brno, Czechoslovakia. The renowned furniture exploited ideas with which others had also experimented: in particular, the "spring quality of steel tubes." In the three commissions awarded to Mies in 1927, furniture played an important role in the definition as well as in the articulation of space.[27] He was not party to those of his architectural colleagues who viewed pure and rational architecture as the basis for realizing utopian dreams or as a means for social reform. Le Corbusier and Gropius shared these beliefs and dreams.[28]

At the BAUHAUS Mies was known for having the most creative and most intellectual relationship with glass. He was uniquely, singularly drawn to this crystalline material. We say "intellectual" as well as "creative" on the grounds of Werner Blaser's demonstration, in his reconstruction of the bonding logic of Mies's Brick County House (1923), that the tectonic means adopted, that is, the bonded solid-wall brick construction was worked out in accordance with the dimensions and proportions of the basic brick module. Philip Johnson, on studying the work of this mid-1920s to mid-1930s period of Mies's career, observed:

> He calculated all dimensions in brick lengths and occasionally went so far as to separate the under-fired long bricks from the over-fired short ones, using the long in one direction and the short in the other.[29]

It was because Mies recognized the potential of an idea and pursued it doggedly to its ultimate technical and aesthetic refinement that he succeeded where others failed. So it was that glass and the idea of exploiting its potential for creating pure glittering

prisms, rather than any "functional" theory, became the generating idea for the early work by Ludwig Mies van der Rohe.[30]

The persistence of this visionary spirit, colliding sometimes with his invariant impulse toward the classic and the standard, distinguishes Miesian "functionalism" throughout his career. Without Mies, the artists and designers of the BAUHAUS would have gone down in history as exclusively concerned to demonstrate that "functionalism" is the source of architectural beauty.[31] Without Mies, Gropius would also have had the last word, when he said that rational architecture meant "starting from zero."[32] Tom Wolfe comments that "starting from zero referred to nothing less than recreating the world."[33] Reflecting on Gropius's prodigous words (nearly 400 publications are mentioned in *Bauhaus*[34]) and his works bears this out.

"Starting from zero" may be apt as a capsule description of the BAUHAUS spirit, but it is misleading when applied to Mies van der Rohe. For, as we have been suggesting, Mies had a profound respect for the tectonic tradition of architecture, struggling throughout his career to achieve a tectonic articulation of the perimeter structure of his "glass houses." It is as absurd to suppose that the cruciform construction Mies employed in his architecture and furniture is a case of "starting from zero" as to suppose that the use of steel tubing exemplifies what the slogan implies. Cruciform construction is as "new" as the Parthenon and as old as the Egyptian temples of the Valley of the Gods at Thebes, which date from about fifteen hundred years before Christ. Anecdotal evidence of Mies's familiarity with the long history of cruciform construction and of his great love for the design of classical Greek temples is supplied by George Nelson who reported the following in 1935:

> As I got up to leave I noticed a beautiful engraving of an Ionic capital, prominent in the modern room and asked Mies what it was doing there. Mies looked at it seriously for a moment before replying. "The old architects," he said finally, "copy this sort of thing. We appreciate it."[35]

When one studies the evolution of Mies's career, one learns that a lucky accident in 1904 reformed his conception of himself and of his work. Mies had taken a job in an architect's office

during that year, where the work table assigned to him happened to have a drawer containing a scientific paper left by a previous draftsman, a paper about the various physical aspects of the structure of the universe. Mies read it. This chance event, "ignited in Mies an interest in science—especially astrophysics—that he retained for the rest of his life," Spaeth observes. "After philosophy, his other great intellectual passion, Mies's reading focused on the sciences."[36] That Mies had these intellectual passions seems to underscore the point George Nelson made in the anecdote cited above. If one appreciates Ionic columns and the philosophers of classical antiquity, it is at best unlikely that one's back will be turned on the history of the Western tradition.

It is also worth noting that when Mies chose to use steel in constructing a building he opted not only for the trabeated frame of the German industrial building tradition (evidenced by the countless steel factories populating the Ruhr and the refinement of this idiom in the hands of architects such as Fritz Schupp), but, by so doing, chose to revitalize a tradition rather than break with it. What is new, and genuinely original, is the use to which Mies put the trabeated frame and his belief that architecture should express the structure, in this case the steel structure, of which it is made. The apartment block Mies contributed to the Weissenhofsiedlung in 1927 was his first steel structure. According to Spaeth, it may have been the clearest expression of the philosophy of the modern movement, since its articulated skeletal structure was clad with light walls that enclosed volume rather than defined mass. Also, the materials were selected for their intrinsic worth and used without applied decoration.

Mies's decision to exploit the potential of glass is another case in point. Our decision to focus attention on the Friedrichstrasse Office Building, rather than the apartment block of 1927, is the consequence of believing that the Office Building illustrates our point with greater clarity. Mies's comments about this building lend support to our contention. He wrote:

> Because I was using glass, I was anxious to avoid enormous, dead surfaces reflecting too much light, so I broke the facades a little in plan so that light should fall on them at different angles: like crystal, cut-crystal. . . . Then I tried to work with smaller areas of

glass and adjusted my strips of glass to the light and then pushed them into a . . . plasticine plane. That gave me the curve, and if people now say that I got that from Arp, I can tell you it had nothing to do with him.[37]

Although Mies was influenced by German Expressionism and Russian Suprematism, we maintain, unlike Spaeth, that Mies translated these movements, particularly the latter, into architectural form. Spaeth praises Mies for articulating "his position clearly, succinctly without philosophic cant."[38] We, however, find no reason to dismiss Mies's philosophical statements as *mere* "cant." On the contrary, we respect Mies, at least in part because we admire his philosophical acumen.[39]

We spoke earlier of Mies's relationship to the architects and designers of the BAUHAUS and to that school's goal of producing artifacts of pure, clear, and rational form. Whereas the BAUHAUS architects and designers were concerned with sociopolitical reform[40] as well as architectural and design form, Mies was apparently apolitical and single-mindedly devoted to finding perfect aesthetic forms. Hughes writes that Mies's designs were "so abstract, so regular, so obsessed with clarity of detail, so fond of the crystalline mass as a single dominating form"[41] that they outstripped the others'. We concur with the letter of Hughes's words, but not with their spirit. Hughes seems intent on portraying Mies as a fanatic; we celebrate him, instead, for being a perfectionist. Kenneth Clark summarizes our point when he writes that "effective revolutions depend on convincing details."[42]

Among the architectural masterpieces of Mies's post-World War II career, one stands out because a Suprematist aura lingers about it even today: the Seagram Building (1958).[43] The fusion of the bronzed mullions with the brown tinted glass, "as though they were both transmutations of the same basic material,"[44] makes it a wonderful and functional monument of Mies's genius. Although it is a structure used daily by the hundreds of people who work in the offices it houses, as well as by the many others who have the good fortune to eat and drink in its two restaurants and peaceful bar, Mies paid little heed to the needs or expressed wishes of these inhabitants and users. As was his wont, he concentrated his dynamic energies on the origination of an aesthetically pleasing work of art. According to Hughes,

Mies van der Rohe was apt to sweep aside questions of meaning within the buildings themselves; they interfered with the perfect Zero that he struggled to approach.[45]

We object. We also remonstrate Charles Jencks for characterizing Mies's approach as evidencing "contempt for place and function."[46] The highlights of the cruciform bronze "I" columns evoke the fluting of the classic Doric order. (The Greeks in their great wisdom also preferred the Doric to the other two classical orders, the Ionian and the Corinthian. It was, indeed, the order of choice for the exteriors of Greek classical temples.) Someone has even suggested that the building looks like a bottle of Seagram's whiskey—from some considerable distance, in a somewhat idealized picture of Manhattan. Although we take this suggestion to be exceedingly fanciful, we mention it as a conceivable interpretation of a type that Hughes or Jencks would countenance as a (strained) effort to show that the Seagram Building has meaning. A second point that an objector might make would charge Mies with wanton disregard for the persons who were to occupy and use this building. Such a charge can also be met, along the following lines. The precision, subtlety, and assurance reflected in both public and private spaces—in the proportions of the rooms as well as in their furnishings (including not only the elegant cutlery in the elegant restaurant on the ground floor, but also the equally elegant bathroom fixtures, used throughout), which are part and parcel of the interior design of the Seagram Building—bespeak a consistency of taste that is not contrary to the task of providing for creature comforts.

One main problem confronting Mies in designing the Seagram Building concerned the addition of curtains.[47] As Mies saw it, curtains would cause two problems. The random addition of curtains or draperies by the inhabitants would interfere with the purity of the building's exterior design. In addition, curtains would interfere with the purity, clarity, and reflective qualities of the glass. His resolution of these problems is, in part, the brown tint of the glass; the other part is his decision to build curtains into the structure, curtains that can be in only one of three predesignated positions: open, closed, and half-way between these two. A compromise? Yes and no. Mies's warm, bronzed masterpiece does, however, generate an air of paradox that we regard as further

evidence in support of our claim that to view Mies as "reason's" paragon is to see but half of his genius.

The plan of the Seagram Building shows that the "I" columns one sees on approaching the building have no weight-bearing function. They are actually extended out and beyond the structure, making the columns into a decorative element, introduced by the architect hailed by myriad critics and countless laypersons as the man who wanted to dispense with ornament.

The paradoxical Ludwig Mies van der Rohe was neither more nor less enigmatic than any other giant among Western men and women.

NOTES

1. Scheerbart, quoted by Robert Hughes in *The Shock of the New* (New York: A. Knopf, 1981), p. 177.

2. Bruno and Max Taut designed individual buildings for the "Weissenhof" housing development, built under the direction of Mies van der Rohe, in 1927. We will have occasion to refer to this housing development below; here we merely wish to clarify the relationships among the persons to whom we refer in this paragraph.

3. Hughes, p. 122.

4. John Hix, *The Glass House* (Cambridge, Mass.: MIT Press, 1974), p. 164.

5. Ibid., p. 162.

6. The term "functionalist" here and throughout the essay is shorthand for the principle that "form follows function," which is to say that the function of an artifact should be the determinant of its shape or form. One illustrative example should clarify the precise meaning of this principle. Consider the challenge that confronts an architect when he or she is commissioned to design and build a prison.

7. When the BAUHAUS moved to Berlin and held its first Carnival Party, Mies was singled out by some of his colleagues as a master of a quite special sort. In her letter, Annemarie Wilke says: "The only [room] coming close to the style of the Mies room was the Peterhans room. . . ." There was evidently a style unique to Mies. As the rest of the letter makes clear, Mies's demeanor was also unique. *Bauhaus*, revised English-language edition, translated by Wolfgang Jabs and Basil Gilbert, edited by Joseph Stein (Cambridge, Mass.: MIT Press, 1969), henceforth: *Bauhaus*, p. 186.

8. David Spaeth, *Mies van der Rohe* (New York: Rizzoli, 1985). Kenneth Frampton's "Preface," pp. 9–10.

9. The epigram of David Spaeth's "Chapter I: 1886–1918" encapsulates the standard understanding of Mies's significance as a pioneering modernist. It is taken from St. Thomas Aquinas, and reads: "Reason is the first principle of all human work." Spaeth continues, retelling the apocryphal story about the young Ludwig Mies (van der Rohe was a later addition to his name) counting stones and tracing mortar joints with his eyes, rather than attending to the transubstantiation of the Eucharist when he attended Mass during his early years in the Aachen Cathedral School (Domschule). It is clear nothing enters into the "standard" story that hints at any kind of utopian vistas. Spaeth, ibid., pp. 19–46.

10. Cited by Frampton, ibid., p. 10.

11. Ibid., p. 9. Frampton cites the play of tinted opaque and oblique glass in the Barcelona Pavilion, the Russian color scheme of the 1927 Exposition de la Mode, and "above all the glass industry suite designed for the Stuttgart Werkbund exhibition" of 1927.

12. Ibid., p. 8.

13. We are not committed to a doctrine as absolutistic as Ernest Bloch's, found in "The Trajectory of Art," *Marxism and Art*, edited by Maynard Solomon (Detroit: Wayne State University Press, 1979), pp. 583–589. Bloch's thesis is that the permanence and greatness of all major works of art consists

> precisely in their operation through a fullness of pre-semblance. They reside, so to speak, in the windows of such works; and *always* in windows which open *in the direction of ultimate anticipation.* (the italics are ours, p. 585)

Our thesis is intended to apply only to Mies van der Rohe.

14. Spaeth, p. 35.

15. Ibid., p. 35.

16. Ibid., p. 56.

17. What Spaeth says of Mies would work better as a description of Gropius. See *Bauhaus,* especially the school curricula Gropius penned. His budget proposal for 1919 also bears out our point. Ibid., pp. 26 ff.

18. Ibid., p. 39. We do not mention the Russian Suprematists in this connection because Spaeth does not.

19. Charles Jencks, *The Language of Post-Modern Architecture* (New York: Rizzoli, 1977), p. 15. We will have occasion to return to Jencks's acerbic criticism below.

20. James A. Speyer, *Mies van der Rohe* (Chicago: Art Institute of Chicago, 1968), p. 14.

21. Robert Hughes, p. 162.

22. Cited by Frampton in Spaeth, p. 7.

23. *Bau und Wohnung: die Bauten der Weissenhofsiedlung in Stuttgart errichtet 1927* [Housing and Residence: Weissenhof Housing Development in Stuttgart, constructed in 1927] (Stuttgart: F. Wedekind, 1927), p. 7.

24. Spaeth, p. 48.

25. Adolf Loos, "Ornament und Verbrechen" ["Ornament and Crime"] (1908), in *Adolf Loos, Saemtliche Schriften in Zwei Baenden [Collected Essays in Two Volumes]* edited by Franz Glueck (Wien: Herold, 1962), p. 277. The original German text reads: "Evolution der Kultur ist gleichbedeutend mit dem Entwerfen des Ornamentes aus dem Gebrauchsgegenstaende." Our term "is equivalent to" is tamer than Loos's "ist gleichbedeutend mit," but should serve.

26. Cited by Frampton in Spaeth, p. 8.

27. Spaeth, ibid., pp. 47–48.

28. See the letters and manifestoes Gropius wrote, *Bauhaus*.

29. Philip Johnson, *Mies van der Rohe* (New York: Museum of Modern Art, 1947), p. 35.

30. Robert Hughes, p. 180.

31. H. W. Janson, *Form Follows Function, or Does It?* (Amsterdam: Academische Press, 1982), p. 5.

32. Walter Gropius, *The New Architecture and the Bauhaus.* (London: Faber and Faber Ltd., 1935), p. 19.

33. Tom Wolfe, "From Bauhaus to Our House," *Harper's* (July 1981): 37.

34. See *Bauhaus*.

35. Cited in Spaeth, p. 47.

36. Spaeth cites this as a personal communication between himself and Georgia van der Rohe, Mies's daughter.

37. Cited by Spaeth, p. 39.

38. Ibid., p. 41.

39. We also question why Jencks calls Mies and/or his buildings "inarticulate" and/or complains that Mies's language is "confusing" both literally and metaphorically. Jencks, p. 151ff.

40. See *Bauhaus*, especially the reference to "Die Soziologischen Grundlagen der Minimalwohnung fuer die Staedtische Industriebevoelkerung," in *Die Justiz* 5, no. 8. (May 1930): 636.

41. Robert Hughes, p. 184.

42. Kenneth Clark, *What Is a Masterpiece?* (London: Thames and Hudson, 1979), p. 30. This is Clark's catchy summary of a position that

is meant to imply that in a master's masterpiece the artist's mastery has been sustained down to the smallest detail—and not that a master's masterpiece marks a decisive break with tradition, or with the master's own historically prior achievements.

43. We do not understand how Jencks arrived at his conclusion that, in the Seagram Building, "Malevich is at odds with Mies." Jencks, p. 121. We are also baffled by some other Jencks complaints, such as the one in which he ridicules Mies for investing the structural elements "with an almost sacred quality, as if they were marble and not industrial material," id., p. 151. That's puzzling in view of the comments we made earlier regarding Mies's willingness to respect and exploit the potentials of each of the materials he selected for his projects. Perhaps it comes down to the differences between Jencks's attitude and ours.

44. Frampton in Spaeth, p. 10.

45. Robert Hughes, p. 184.

46. Jencks, p. 15. Jencks's comments make it clear that he views Mies as "obsessed by perfecting certain formal problems" at the expense of concern with humane or even functional considerations. Such extremist talk seems unhelpful as well as unwarranted.

47. Tom Wolfe, p. 43.

Postscript

In view of the diversity of topics tackled in these eight essays, a postscript may be in order if the philosophical problems they endeavor to resolve are to be understood fully.

Alice Montag indicates that a major problem is raised by the practices of the market place, a variant of a problem as old as Western philosophy itself, viz.: what is the nature and/or status of artworks in a complex society? In suggesting that we are presently inclined to treat them as consumer goods, she implicitly argues that we have forgotten that major works of creative art should be treated as artistic and spiritual triumphs: torchbearers of our shared values.

By raising questions about the meaning of the slogan that art is for art's sake, Leslie Birch reminds us of the difficulties involved in elucidating the notion of intrinsic, as distinct from extrinsic, value. A Kantian maneuver is implicit here, one intended to teach that entities of intrinsic value are such that they overcome the common-sense distinction between means and ends. "We cannot will an end," Kant said, "unless we are prepared to will some way of achieving it."[1] In short, the claim is that we prize both the process of creating and the product that issues from it.

Both Anne Eu and Maria Quillard premise their arguments on the thesis examined by Leslie Birch. These two essays, therefore, raise yet a deeper issue, namely, whether great art must necessarily be symbolic, i.e., whether artworks that are entirely non-figurative or nonobjective can "articulate ideas of something we wish to think about" and, as Suzanne Langer puts it, enable us to do this since we are "without a fairly adequate symbolic system

141

[without which we] cannot think about it."[2]

Inga Freivalds's essays on Mies van der Rohe speaks to this very point. By her lights, Mies's architectural masterpieces are symbols in Langer's sense. That they succeed in this immeasurably increases their expressive potentialities.

Kyra Reppen opens once more the debate regarding photography's status: is it a minor art or one whose masterpieces should rank among man's major artistic achievements? Has photography the fatal disadvantage of conceptual inflexibility? I believe Reppen would not diagnose it as suffering this fatal flaw. But even so, she leaves us with a perennial philosophical question: of what value is a visual image, or a visual record?

Elizabeth Alford and Jennifer Garden may well be said to be the least philosophically oriented contributors. They are, unless one is prepared to call the task of setting the historical record straight an instance of the philosophical impulse to uncover or discover truth.

One final concluding remark: Although the Introduction makes mention of a dominant unifying theme—the growing disaffection with an "anything goes" attitude toward the arts—there is little explicit reference to it in the essays themselves. But in writing the essays included in this volume, each of the authors comes down on the side of taking the risk of articulating a critical (evaluative) judgment. This is *the* path leading to the community of values we long for.

NOTES

1. This formulation of Kant's teaching is taken from William H. Gass's essay "The Stylization of Desire" in his *Fiction and the Figures of Life* (New York: Vintage Books, 1972), p. 197.
2. Suzanne K. Langer, *Feeling and Form* (New York: Charles Scribner's Sons, 1953), p. 28.

Bibliography

Ackerman, J. "On Judging Art Without Absolutes." *Critical Inquiry* 5, no. 3 (Spring 1979): 441–469.

Adams, Ansel. *Making a Photograph*. New York: Studio Publications, 1935.

Adams, Hugh. "Against a Definitive Statement on British Performance Art." *Studio International* (July-August 1976): 3–9.

Adorno, Theodor W. *Prisms*. Cambridge, Mass.: MIT Press, 1982.

ARTnews 85, no. 2 (February 1985), esp. Paul Gardner, "The Electronic Palette," pp. 66–73.

Bate, W. Jackson. *The Burden of the Past and the English Poet*. New York: W. W. Norton, 1972.

Battcock, Gregory. "L'Art Corporel." In the catalog *The Art of Performance*. Venice: Palazzo Grassi, 1979.

"Bau und Wohnung: die Bauten der Weissenhofsiedlung," in *Stuttgart errichtet 1927*. Stuttgart: F. Wedekind, 1927.

Baudelaire, Charles. "The Salon of 1859: The Modern Public and Photography." In *Modern Art and Modernism: A Critical Anthology*, edited by Francis Frascani and Charles Harrison. New York: Harper and Row, 1982.

Bayer, Jonathan. *Reading Photographs: Understanding the Aesthetics of Photography*. The Photographers' Gallery. New York: Pantheon, 1977.

Benjamin, Walter. "The Work of Art in the Age of Mechanical Reproduction." In *Marxism and Art*, edited by Maynard Solomon. Detroit, Mich.: Wayne State University Press, 1979.

Berlin, Isaiah. *Personal Impressions*. New York: Viking, 1980, p. xiii.

Broude, Norma and Mary D. Garrard. *Feminism and Art History*. New York: Harper and Row, 1982.

Butler, Samuel. *The Authoress of the Odyssey*. Chicago: The University of Chicago Press, 1967.

Carlson, Prudence. "Donald Judd's Equivocal Objects." *Art in America* 72, no. 1 (January 1984): 114–118.

Carrier, David. "Greenberg, Fried, and Philosophy: American Type Formation." In *Aesthetics: A Critical Anthology*, edited by George Dickie and Richard Scalafani, pp. 461–468. New York: St. Martin's Press, 1977.

Cavell, Stanley. "Aesthetic Problems of Modern Philosophy" In *Philosophy in America*, edited by Max Black. Ithaca, New York: Cornell University Press, 1965.

Chipp, Hershell B., ed. *Theories of Modern Art: A Source Book*. Berkeley and Los Angeles, Calif.: University of California Press, 1971.

Clark, Kenneth. *What Is a Masterpiece?* London: Thames and Hudson, 1979.

Danto, Arthur C. "The Last Work of Art: Artworks and Real Things." In *Aesthetics: A Critical Anthology*, edited by George Dickie and Richard Scalafani, pp. 551–562. New York: St. Martin's Press, 1977.

———. *The Transfiguration of the Commonplace*. Cambridge, Mass.: Harvard University Press, 1981.

Dickie, George and Richard Scalafani. *Aesthetics: A Critical Anthology*. New York: St. Martin's Press, 1977.

Di Felice, Attanasio. "Renaissance Performance: Notes on Prototypical Artistic Actions in the Age of the Platonic Princes." In *The Art of Performance: A Critical Anthology*, edited by Gregory Battcock and Robert Nichas, pp. 3–23. New York: Dutton, 1984.

Donoghue, Dennis. *The Arts Without Mystery*. Boston: Little, Brown, 1983.

DuChamp, Marcel. "Art as Non-Aesthetic: I Like Breathing Better Than Working." In *Aesthetics: A Critical Anthology*, edited by George Dickie and Richard Scalafani, pp. 540–547. New York: St. Martin's Press, 1977.

Eco, Umberto. *Semiotics and the Philosophy of Language*. Bloomington, Ind.: Indiana University Press, 1984, pp. 14–45.

Eliot, T. S. "Tradition and the Individual Talent." In *Selected Essays*, pp. 3–11. New York: Harcourt Brace, 1932.

Engell, James. *The Creative Imagination: Enlightenment to Romanticism*. Cambridge, Mass.: Harvard University Press, 1981.

Fine, Elsa Honig. *Women and Art*. Montclair, N.J.: Allanheld and Schram/Prior, 1978.

Foot, Philippa. "Morality and Art." In *Philosophy as It Is*, edited by Ted Honderich and Miles Burnyeat, pp. 13–29. New York: Penguin, 1979.

Foster, Hal, ed. *The Anti-Aesthetic: Essays on Post-Modern Culture*. Port Townsend, Wash.: Bay Press, 1983.

Frank, Elizabeth. *Jackson Pollock*. New York: Abbeville Press, 1983.

Fried, Michael. "Art and Objecthood." In *Aesthetics: A Critical Anthology*, edited by George Dickie and Richard Scalafani, pp. 438–460. New York: St. Martin's Press, 1977. (Originally published in *Minimal Art: A Critical Anthology*, edited by Gregory Battcock. New York: Dutton, 1968.)

————. "How Modernism Works: A Response to T. J. Clark." *Critical Inquiry* 9, no. 1 (September 1982): 217–234.

————. "Representing Representation: On the Central Group in Courbet's 'Studio.' " *Art in America* 69, no. 7 (September 1981): 127–133, 168–173.

————. "The Structure of Beholding in Courbet's 'Burial at Ornans.' " *Critical Inquiry* 9, no. 4 (June 1983): 635–683.

————. *Three American Painters: Kenneth Noland, Jules Olitski, Frank Stella*. Exhibition catalog. Cambridge, Mass.: Fogg Art Museum, 1965.

Fry, Roger. "Some Questions in Esthetics." In *Transformations*. New York: Doubleday Anchor, 1956.

Furlong, E. J. *Imagination*. New York: Macmillan, 1961.

Gallie, W. B. "Essentially Contested Concepts." *Proceedings of the Aristotelean Society* 36 (1945–1946): 167–198. Also in *The Importance of Language*, edited by Max Black, pp. 121–146. Englewood Cliffs, N.J.: Prentice-Hall, 1962.

Gans, Herbert J. *Popular Culture and High Culture: An Analysis*

and Evaluation of Taste. New York: Basic Books, 1974.

Gass, William H. *Habitations of the Word.* New York: Simon and Schuster, 1985.

Glaser, Bruce. "Questions to Stella and Judd." *ARTnews* (September 1966): 55–61.

Goldberg, Rose Lee. "Oskar Schlemmer's Performance Art." *Artforum* 16, no. 1 (September 1977): 32–37.

Gombrich, Ernst H. *Art and Illusion.* London: Phaidon, 1960.

———. *Meditations on a Hobby Horse.* London: Phaidon, 1963.

Goodman, Nelson. *Ways of Worldmaking.* Indianapolis, Ind.: Hackett, 1978.

———. "Art and Inquiry." In *Modern Art and Modernisms: A Critical Anthology,* edited by Francis Frascina and Charles Harrison, p. 191. New York: Harper and Row, 1982.

Greenberg, Clement. "After Abstract Expressionism." *Art International* 6, no. 8 (October 1962): 26–29.

———. *Art and Culture.* Boston: Beacon, 1961. (Originally published in 1948.)

———. "Jean Dubuffet, Jackson Pollock." *The Nation* 164 (February 1, 1947): 137.

———. "Louis and Noland." *Art International* 4, no. 5 (1945): 26–29.

———. "Modernist Painting." In *The New Art: A Critical Anthology,* edited by Gregory Battcock, pp. 100–110. New York: Dutton, 1966. (First published in *Art and Literature* 4 [Spring 1965].)

———. "The New Sculpture." In *Art and Culture,* pp. 139–145. Boston: Beacon, 1961.

Gropius, Walter. *The New Architecture and the Bauhaus.* London: Faber and Faber, 1935.

Guyer, Paul. *Kant and the Claims of Taste.* Cambridge, Mass.: Harvard University Press, 1979.

———. "Pleasure and Society in Kant's Theory of Taste." In *Essays in Kant's Aesthetics,* edited by Ted Cohen and Paul Guyer. Chicago: The University of Chicago Press, 1982.

Hager, Steven. *Hip Hop.* New York: St. Martin's Press, 1984.

Haskell, Barbara. "Two Decades of American Sculpture: A Survey." In *Two Hundred Years of American Sculpture,* edited by Tom Armstrong, pp. 186–213. Boston: Godine, 1976.

Hauser, Arnold. *The Social History of Art.* Translated by Stanley

Godman. New York: Vintage, 1951.

Hess, Thomas B. "Great Women Artists." In *Art and Sexual Politics*, edited by Thomas B. Hess and Elizabeth C. Baker, pp. 44–54. New York: Macmillan, 1973.

Hix, John. *The Glass House*. Cambridge, Mass.: MIT Press, 1969.

Hughes, Robert. "On Art and Money." *New York Review of Books* 31, no. 19 (December 6, 1984): 20–27.

———. *The Shock of the New*. New York: A. Knopf, 1981.

Hume, David. "Of the Standard of Taste." In *Hume's Ethical Writings*, edited by Alasdair MacIntyre, pp. 275–295. London: Collier Books, 1965. (Also published in New York by St. Martin's Press, 1984.)

———. *A Treatise of Human Nature*, edited by L. A. Selby-Bigge. Oxford: Clarendon, 1951. (First edition, 1888.)

Janson, H. W. *Form Follows Function or Does It?* Amsterdam: Academische Press, 1982.

Jencks, Charles. *The Language of Post-Modern Architecture*. New York: Rizzoli, 1977.

Johnson, Philip. *Mies van der Rohe*. New York: The Museum of Modern Art, 1947.

Kant, Immanuel. *Critique of Aesthetic Judgement*. Translated by James Creed Meredith. Oxford: Clarendon, 1911.

Kontoua, Helen. "From Performance to Painting." *Flash Art* 10 (February–March 1982).

Krauss, Rosalind. "Changing the Work of David Smith." *Art in America* 62 (September 1974): 30–34.

———. *Passages in Modern Sculpture*. Cambridge, Mass.: MIT Press, 1981. (Originally published by Viking Press, New York, 1977.)

———. "Sculpture in the Expanded Field." In *The Anti-Aesthetic*, edited by Hal Foster, pp. 31–42. Port Townsend, Wash.: Bay Press, 1983.

Kris, Ernst. *Psychoanalytic Explorations in Art*. New York: International University Press, 1965.

Lang, Berel, ed. *The Concept of Style*. Philadelphia, Penn.: University of Pennsylvania Press, 1979.

Loeb, Judy, ed. *Feminist Collage*. New York: Teacher's College Press, 1979.

Loos, Adolf. "Ornament und Verbrechen." (1908). In *Saemtliche Schriften in Zwei Baenden*, edited by Franz Glueck, p. 277. Vienna: Herold, 1962.

Mann, Thomas. *Doctor Faustus*. Translated by H. T. Lowe-Porter. New York: Vintage, 1971.

Maritain, Jacques. "Art as a Virtue of the Practical Intellect." In *Art and Philosophy*, edited by William Kennick, pp. 62–77. New York: St. Martin's Press, 1964.

Morris, Robert. "Notes on Sculpture." In *Minimal Art: A Critical Anthology*, edited by Gregory Battcock, pp. 222–235. New York: Dutton, 1968.

Newhall, Beaumont. *The History of Photography from 1839 to the Present Day*. New York: The Museum of Modern Art, 1949.

Nochlin, Linda. "Towards a Juster Vision." In *Feminist Collage*, edited by Judy Loeb, pp. 3–13. New York: Teacher's College Press, 1979.

———. "Why Have There Been No Great Women Artists?" In *Art and Sexual Politics*, edited by Thomas B. Hess and Elizabeth C. Baker, pp. 1–42. New York: Macmillan, 1973.

O'Connor, Francis V. *Jackson Pollock*. New York: The Museum of Modern Art, 1967.

———. "The Life of Jackson Pollock, 1912-1956." In *Jackson Pollock: A Catalogue Raisonne of Paintings, Drawings, and Other Works*, edited by O'Connor and Eugene Victor Thaw, vol. 4. New Haven, Conn.: Yale University Press, 1978.

O'Neill, Hank. *Berenice Abbott American Photographer*. New York: McGraw-Hill, 1982.

Parker, Roszika and Griselda Pollock. *Old Mistresses*. London: Routledge and Kegan Paul, 1981.

Perrault, John. "A Minimal Future? Union-Made." *Arts Magazine* 41, no. 5 (March 1967).

Plekhanov, Georgi. "The Role of the Individual in History." In *Marxism and Art*, edited by Maynard Solomon, pp. 119–127. Detroit, Mich.: Wayne University Press, 1979.

Poggioli, Renato. *The Theory of the Avant-Garde*. Translated by Gerald Fitzgerald. New York: Harper and Row, 1974.

Read, Herbert. *The Art of Sculpture.* New York: Pantheon, 1956.

Russell, John. *The Meanings of Modern Art.* New York: The Museum of Modern Art, 1974; Harper and Row, 1981.

Schapiro, Meyer. *Paul Cezanne.* New York: Abrams, 1952.

Scheffler, Israel. *Beyond the Letter.* London: Routledge and Kegan Paul, 1979.

Shaw, Bernard. *Shaw on Music,* edited by Eric Bentley. New York: Doubleday, 1955

Sibley, Frank. "Aesthetic Concepts." In *Philosophy Looks at the Arts,* edited by Joseph Margolis, pp. 63–88. New York: Charles Scribner's Sons, 1962.

Spaeth, David. *Mies van der Rohe.* Preface by Kenneth Frampton. New York: Rizzoli, 1985.

Speyer, James A. *Mies van der Rohe.* Chicago: Art Institute of Chicago, 1968.

Stein, Joseph. *Bauhaus.* Revised English-language edition, translated by Wolfgang Jabs and Basil Gilbert. Cambridge, Mass.: MIT Press, 1969.

Steiner, George. *Extraterritorial: Papers on Literature and the Language Revolution.* New York: Atheneum, 1976.

Summers, David. "Conventions in the History of Art." *New Literary History* 13, no. 1 (Autumn 1981): 103–125.

Tolstoy, Leo. *What Is Art?* Translated by Aylmer Maude. London: Oxford University Press, 1930. (Originally published in 1898.)

Tucker, William. *Early Modern Sculpture.* New York: Oxford, 1974.

Waismann, F. "Verifiability." In *Logic and Language,* edited by A. Flew, pp. 117–144. First series. Oxford: Oxford University Press, 1951. (Originally published in *Proceedings of the Aristotelean Society,* suppl. vol. 19, 1945.)

Weitz, Morris. *The Opening Mind.* Chicago: The University of Chicago Press, 1977.

Woelfflin, Heinrich. *Principles of Art History: The Problem of the Development of Style in Later Art.* Translated by M. D. Hottinger. 7th ed. New York: Dover, 1942. (Originally published in 1929.)

Wolfe, Tom. *From Bauhaus to Our House*. New York: Farrar, Straus, and Giroux, 1981.

———. *The Purple Decades*. New York: Berkeley Books, 1983.

———. "The Worship of Art." *Harper's* (October 1984): 61–68.

Wollheim, Richard. *Art and Its Objects*. New York: Harper and Row, 1968.

———. *On Art and the Mind*. Cambridge, Mass.: Harvard University Press, 1974.

Index